DONCASTER PUBS

PUBS

THE TOWN CENTRE

PETER TUFFREY

AMBERLEY

ABBREVIATIONS

Anelay's account books: Thomas Anelay's cash books of the late eighteenth century. (D.M.B.C. Library Service, Archives Dept).

Don. Chron.: Doncaster Chronicle.

Don. Court.: Doncaster Corporation (1902) *A calendar to the record of the Borough of Doncaster. Vol I. V: Courtiers of the Corporation, Doncaster.*

Don. E. Post: Doncaster Evening Post.

Don. Free Press: Doncaster Free Press.

Don. Gaz. Dir.: Doncaster Gazette Directory.

Don. J.: Doncaster Journal.

Don. Star: Doncaster Star.

D.M.B.C.: Doncaster Metropolitan Borough Council.

D.N.L. Gaz.: Doncaster, Nottingham and Lincoln Gazette.

pers. comm.: personal communication.

Sykes Papers: Notes on old deeds formerly in the possession of Dr Sykes by Rev. W. C. Boulter (D.M.B.C. Library Service).

Yorks. E. Post: Yorkshire Evening Post.

BIBLIOGRAPHY

Baines, E. (1822) *History, Directory, and Gazetteer of the County of York*. Vol. 1: West Riding, Leeds.

Doncaster Gazette Directories 1891-1915.

Hatfield, C. W. (1866-70) *Historical Notices of Doncaster*. 3 Vols. Doncaster.

Jackson, C. (1881) *Doncaster Charities Past and Present*. Worksop.

Kelly, E. R. (1877 and 1899) *The Post Office Directory of the West Riding of Yorkshire*. London.

Parry, D. and Parry, D. (1983) *Bygone Breweries of South Yorkshire*. Manchester.

Register of Licenses (Doncaster Law Courts).

Register of Licenses (D.M.B.C. Library Services, Archives Dept).

Scargill, C. M. and Scargill, S. F. [1989] *The Mason's Arms, Market Place, Doncaster*. Unpl.

Tomlinson, J. (1887) *Doncaster From the Roman Occupation to the Present Time*. Doncaster.

White, F. (1862) *Directory and Topography of Sheffield including the Towns and Villages Twenty Miles Around*. Sheffield.

White, W. (1837) *History, Gazetteer and Directory of the West Riding of Yorkshire*. Sheffield.

White, W. (1867) *Directory of the East Riding of Yorkshire*. Sheffield.

First published 2010

Amberley Publishing
Cirencester Road, Chalford,
Stroud, Gloucestershire, GL6 8PE

www.amberley-books.com

Copyright © Peter Tuffrey 2010

The right of Peter Tuffrey to be identified as the Author of this work has been asserted in accordance with the Copyrights, Designs and Patents Act 1988.

ISBN 978-1-4456-0118-2

British Library Cataloguing in Publication Data.
A catalogue record for this book is available from the British Library.

Typeset in 10pt on 12pt Sabon.
Typesetting and Origination by Amberley Publishing.
Printed in the UK.

DONCASTER PUBS

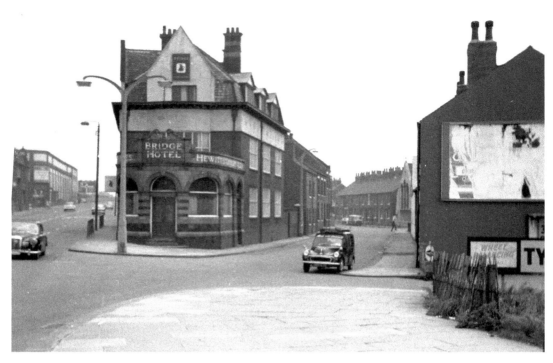

The Bridge Hotel, Marsh Gate, which replaced the Labour in Vain, demolished for the construction of North Bridge. The Bridge Hotel in turn was demolished c. 1972.

Behind the hoardings is the Old Exchange Brewery Tavern, long since defunct as a pub and awaiting demolition c. 1982 for the construction of the Colonnades shopping precinct.

CONTENTS

ACKNOWLEDGEMENTS

I would like to thank the following people for their help:

Malcolm Barnsdale; Alec Birtles; Rod and Val Brodie; Simon Clark; Malcolm Dolby; Geoff Harrison; Terry and Denise Hull; Ron Jones; Philip Langford; Paul Licence; Martin Limbert; Terry and Sharon Oates; Hugh Parkin; Derek Porter; Alan Smith; Tristram Tuffrey; Alan Walker.

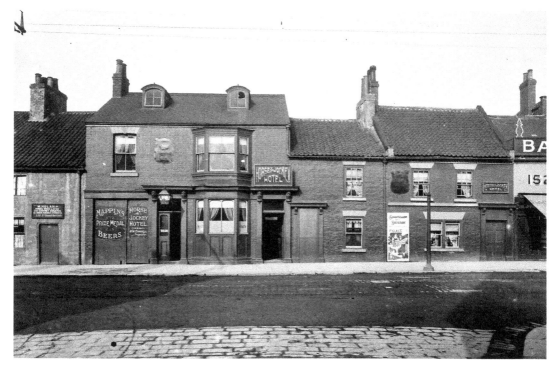

The Horse & Jockey in St Sepulchre Gate West being demolished *c.* 1912, prior to rebuilding.

INTRODUCTION

I first became interested in Doncaster pubs around 1983. It was not that I was a heavy drinker and desired to know every detail about the ones I frequented, I was just eager to prove or disprove many myths and untruths in circulation.

So I embarked on a task of unravelling the history of every Doncaster pub in existence, or that had existed, in the town centre. Where did I begin? First of all I enlisted the help of my old mate James Edward 'Ted' Day, who was then in his eighties. He was the unofficial doyen of the town's history and over his long years had made wads of notes taken from various sources. But he had not done any specific research on pubs and the information he had about them was scattered over his notes.

He was known at times to be quite cantankerous but with my constant leg pulling we formed a good working relationship and developed a system for the task ahead.

Taking each Doncaster pub name that had ever been mentioned we set about tracing how far back its roots extended, using trade directories, newspapers and books. Among the latter was Charles William Hatfield's three-volume work *Historical Notices of Doncaster* (1866-70). These books are full of waffle, Victorian verbiage, but nevertheless provided a starting point. Ted was housebound so he was happy to have the job of trying to discover a pub's earliest located reference. Also Ted's lists of newspaper references extended from the 1780s to 1900. So it was up to me to tackle the newspapers in the twentieth century, discovering when new pubs were built or opened, and old ones rebuilt or closed. I also examined the Doncaster Corporation's minutes, particularly ones involving the Sanitary and Highway Committees, as well as building plans and licensing registers held in both Doncaster Archives and Doncaster Law Courts.

Another very capable local history master who in time took over Ted's mantle was Doncaster Civic Trust Secretary, Eric Braim. A former architect, he provided invaluable information as well as general support. Mention should also be made of Geoff Elvin, a long-time stalwart of Doncaster Trades and Labour Club, who also handed over vital information.

Several interesting observations were eventually made: some inns had existed for a good many years and were associated with the coaching trade; a number sprung up at the time of Doncaster's growth into a thriving railway community; a few were rebuilt as Doncaster Corporation's street-widening programme began in the 1890s; several fell

by the wayside as a result of redundancy and/or introduction of new health legislation; a handful were demolished as a result of slum clearance and road developments in the 1960s; the town is no longer a residential area but one for commerce and business; breweries have adapted their pubs to meet this new criteria.

It was interesting to note that several breweries formerly existed in the town and possessed their own tied houses. A remarkable adventure in recent times was Cooplands establishing the miniature Stocks Brewery at the rear of the Hallcross. To sum up then, on the research side: this book is an honest presentation of facts that provides the reader with references should he or she want to argue with some conviction about the town's public house history.

Illustrations have come from many sources and include old prints, watercolours and architectural drawings as well as photographs from glass plates and picture postcards.

Around the late 1980s I befriended Licensed Victualler's stalwart and President Terry Oates who introduced me to many of the town centre landlords. This was very useful in helping me to persuade each one of them to pose outside their pub with regulars for a few minutes while ex-*Doncaster Evening Post* Chief Photographer Geoff Harrison took pictures of them.

This is now an invaluable record not only because a number of pubs have been demolished, such as the Toby Jug and the Vine, but quite a few have changed names including the Gallery, Gate House, Sidings, and Yorkshireman.

Also, as may have been predicted, very few of the landlords photographed back in the late 1980s are now occupying the same pubs.

Geoff Wagstaffe had the dubious honour of being the former licence holder of two doomed pubs, the Prince of Wales and the Windmill, yet he contacted many of the old guard licensees on my behalf asking them to look through their archives for old pub photographs. John Cuttriss also made available his grandfather Bernard's collection, which included some gems of the original Cleveland Arms, Golden Ball and Scarboro Arms being demolished.

It was disappointing that the vast archives of pictures and information once held by breweries have now long since disappeared or are simply not made available to researchers.

Finally, if I have a favourite pub picture it is the one of the Butchers' Arms in Marsh Gate, now long gone. Although the photograph is a little battered it depicts many people frequenting the small pub, essentially a beer house, yet everyone is anxious and keen to be associated with the house and be included in the picture.

So raise your glasses to Doncaster town centre pubs past and present, whether you are a history buff or not. In any event, it's just an excuse to have a drink and get pissed.

Peter Tuffrey
August 2010

For all Doncaster Landlords past and present

AIRPORT HOTEL – BUTCHERS ARMS

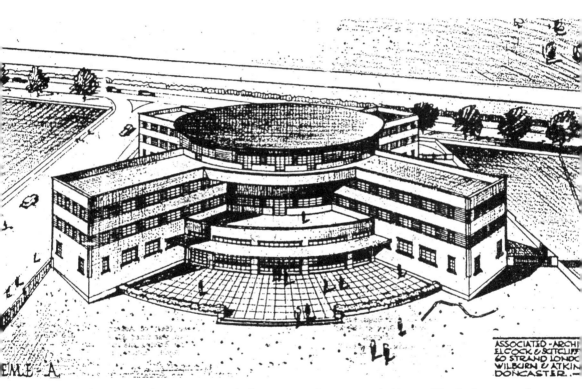

During the late 1930s there was a grand plan to erect the mammoth Airport Hotel, almost on the site occupied by the Dome Leisure Centre. At that time Doncaster was on the brink of becoming a major airport. However, on 18 May 1939, three months after the provisional licence was obtained, the Doncaster Corporation Highways Committee Minutes record that 'a letter was read from W. Lindsay and Bracewell intimating with respect to the proposed Airport Hotel that it was not the intention of G. Hewitt to proceed further in connection with the licence this year.'

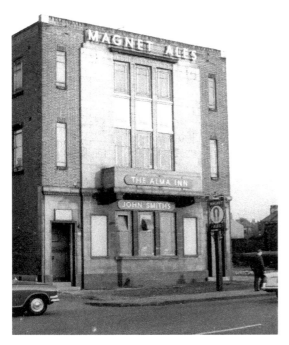

Situated at the junction of Burden Lane and St Sepulchre Gate, the original Alma Inn's exact opening date is unknown. However it is likely to have been between 1854, when the Battle of the Alma took place in the Crimea (after which the inn was probably named) and 1860, which is the earliest located reference. It was built, opened and initially run by Henry Senior, who had a sand business in the area and was the owner of the Sand House and tunnels with carvings, situated nearby. The 1871 Census shows Henry and his family living at the Alma Inn, and he also ran the Don Castle brewery. Initially housed in a building in The Backway (now Market Road), it was later transferred a few yards to a more prominent position in the Market Place. He also ran the Labour in Vain in Marsh Gate, which he subsequently rebuilt.

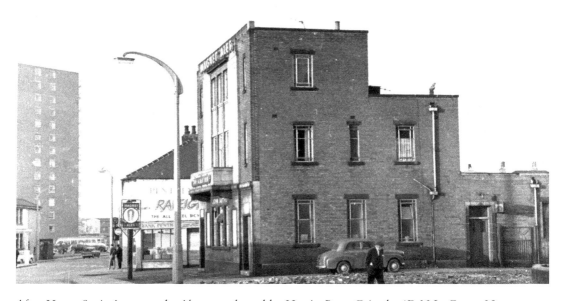

After Henry Senior's tenure the Alma was leased by Hewitt Bros, Grimsby (*D.N.L. Gaz.* 2 Nov. 1883) and in time was sold to Thomas Windle, and later Wath brewers Whitworth, Son & Nephew took over and rebuilt the premises in 1936 to the designs of local architects Wilburn & Atkinson. The pub was granted a full licence in 1949 (*Don. Chron.* 19 Jan. 1949) and was the first one in Doncaster to have a TV set. The rebuilt Alma survived only thirty years and was demolished during July 1966.

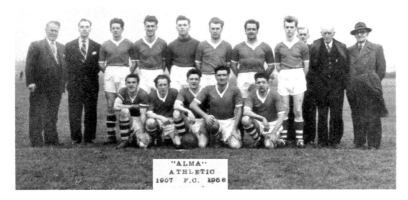

"ALMA"
ATHLETIC
1907 F.C. 1958

The last licensee of the Alma was Stan Parker, who described life in the pub during those final years:

> We went to the Alma in 1954 and the pub was a big rambling place especially upstairs, the entrance to the off-sales was on Burden Lane, and there was a large flat-roofed concert room at the back. No trace could be seen of the original pub. A lot of the old customers told me that they started building the back of the new pub while the front of the old one was still standing. To the rear of us there was mostly just flat land and that's where the Sand House used to be. During the time we were in the pub, some gypsies camped on the site. In those days in the pub it was different to what pub life is today because it was darts, dominoes and the football team [seen above]. A large percentage of our clientele was local. That's why we had a bit of a rough time during those last years. There were no houses around us and I had to go out and get a job to make ends meet. When the pub closed, the council moved us to Cantley.

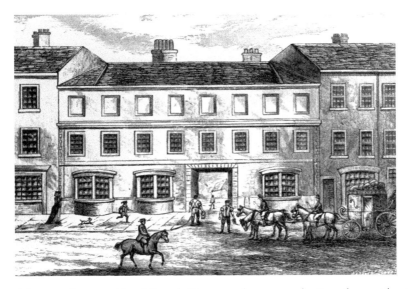

The Angel Inn, on the east side of French Gate, was known as the Bear from at least 1451 and the Angel from 1651. The inn was frequented by many noted people, including Oliver Cromwell who stayed there in 1648. A former landlord of the inn opened the New Angel on the opposite side of the road in 1810, the older establishment surviving the competition until closing in 1838.

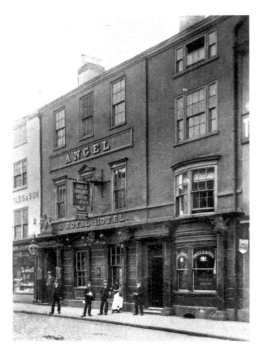

After a troubled start, but being conveniently situated on the Great North Road, the New Angel quickly became Doncaster's principal hotel. Many coaches ran from there daily, including the Carlisle and Glasgow Mail to London every morning at three, returning north at half past six in the evening, and the York and Edinburgh Mail to London every morning at five, returning to the north at half past six in the evening.

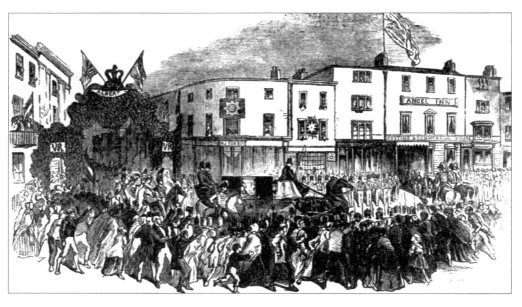

A prominent list of guests stayed at the New Angel, as local historian Charles William Hatfield notes in 1870: 'The Archbishop of York, Bishop of London, Sir Charles Napier, Earl Spencer, Lord Denham, Earl of Derby, Earl De Grey, Earl of Carlisle ...' The New Angel's most outstanding guests however, were Queen Victoria, Prince Albert, the Prince of Wales, the Princess Royal, Prince Alfred and the Princess Alice, who spent a night there on 27 August 1851 while on their way to Balmoral.

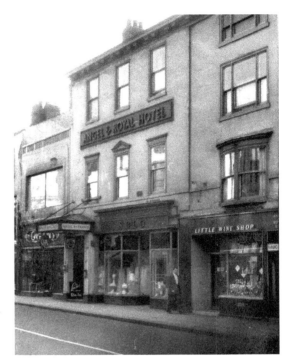

After the visit, the hotel was styled Angel & Royal, and for some years the room in which the Queen had slept was maintained and appropriately titled the 'Queen's room'. In September 1857, Charles Dickens was one of the hotel's guests.

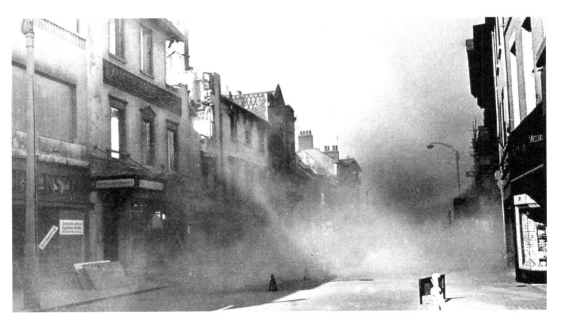

Sadly, the New Angel, suitable for Queen Victoria's needs, and for so long the town's most noted hotel, was demolished in the 1960s to make way for the Arndale (now French Gate) Centre. The *Doncaster Chronicle* of 3 January 1963 reported: 'The last pints were pulled (on 30 December, 1962) at 11.30 p.m. – the New Year's Eve extension had been brought forward – and regulars 'dug in' to a huge iced cake baked by a customer to commemorate the closing.'

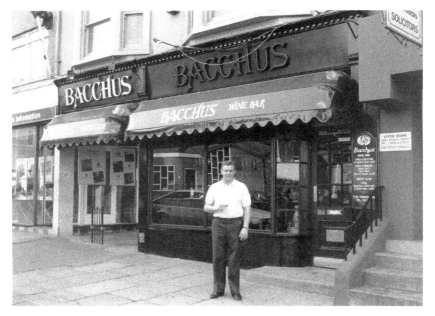

The date of the original grant of a licence (Drinks to be served with a meal – Licensing Register, Don Law Courts) for the Bacchus Wine Bar, Hall Gate, was to Azhar Hamid Shore on 31 January 1976. This licence was surrendered on 6 December 1988 and another issued from the same date. Also, the premises were re-titled 'Bacchus' (refs as above). Past owners have included J. R. J. Properties and Joshua Tetley. In recent years the premises have become a club, titled the Purple Door (*Don. Advertiser,* 17 April 2003).

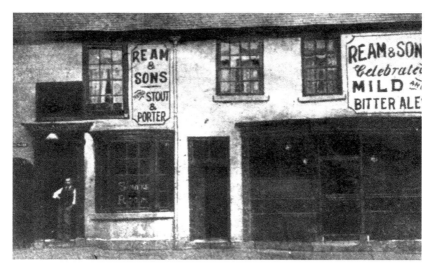

Dating from at least 1829 (Hatfield III: 60) the Bay Horse, French Gate, was demolished *c.*1909 due to the construction of the North Bridge and rebuilt (plans approved 24 Nov. 1908 for C. A. Ream) on a site slightly south of its original position.

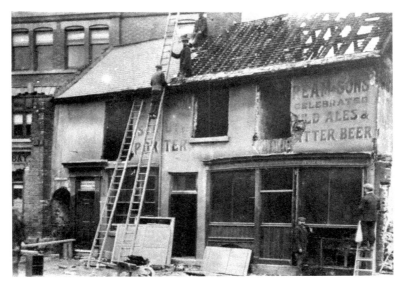

The original Bay Horse is being demolished for the construction of North Bridge. The new building may be seen in the background on the left.

The past owners of the Bay Horse, French Gate, included Samuel Johnson & Sons of Wath; Alfred Ream & Son, Doncaster, who paid £2,100 in 1894 (*Don. Gaz.* 19 Oct. 1894); Bass, Ratcliffe & Gretton Ltd of Burton upon Trent. The rebuilt premises were demolished during November 1966.

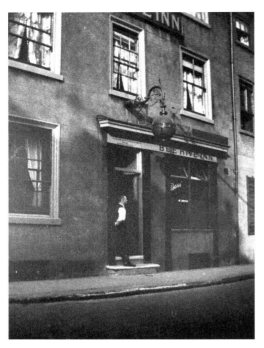

A 'Bee Hive' is noted in 1840 (*D.N.L. Gaz.* 4 Sept. 1840) but it has not been possible to identify the location. However the Factory Lane Bee Hive, a beer house owned by William Henger, may be traced to at least 1867 (*D.N.L.Gaz.* 31 May 1867). A notice in the *D.N.L. Gaz.* 13 August 1880 revealed:

> [Last Friday 6 August 1880] Mr Hope offered for sale by public auction the dwelling house in Factory Lane used as a furniture warehouse and beerhouse, and known as the Bee Hive. The auction attracted a good crowd and, after spirited competition, the sale was declared open at the bid of Mr Whitworth, brewer of Wath. When the auctioneer failed to obtain a higher bid, the property was knocked down to Mr Whitworth for £1000.

An ancient well was found under the floor of the old Bee Hive during demolition in 1940 (*Don. Chron.* 27 June 1940). The original Bee Hive public house is seen above with former landlord G. Muscroft standing outside.

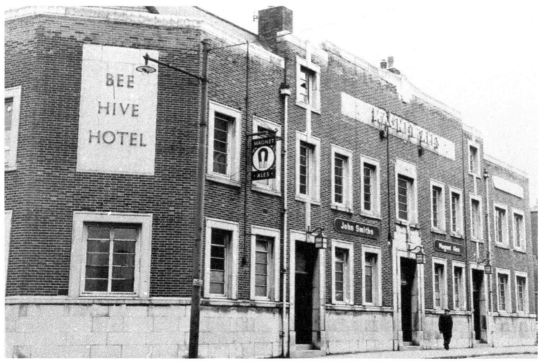

The Bee Hive was rebuilt by Whitworth, Son & Nephew in 1938 for the widening of Factory Lane, surviving until *c.* 1973 when it was demolished for the Arndale (now French Gate) Centre construction. These premises had been granted a full licence in 1948 (*Don. Chron.* 5 Feb 1948).

Joshua Beetham, born in Hooton Pagnell *c.* 1725, began his family's connection with the liquor trade *c.*1760. It is not confirmed, however, whether Joshua's business originated in Doncaster's St George Gate or even in the town itself. In a *Doncaster Chronicle* article, 25 October,1962, it is stated:

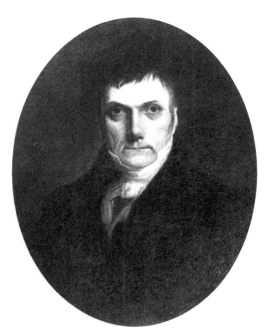

> There was a great deal of brewing and drinking activity in St George Gate as early as 1700. On Midsummer Day in 1700 George Wade signed a bill of particulars which read, under the heading of St George Gate: Mr Thomas Senior, tippler; Mr Joseph Ward, brewer; Mr Thomas Tymm, tippler; Mr Henry Houghton, tippler ... tippler here is the old version of the modern 'tipler', but in those days its meaning was not one who is an enthusiastic drinker, but a retailer of ale and other intoxicants, a tapster or tavern keeper. It seems certain, therefore, that besides a brewery St George Gate contained four taverns. One of these was almost certainly the forerunner of Beethams.

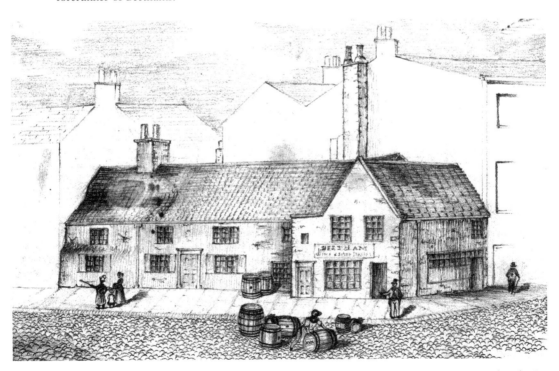

The earliest located reference to Joshua Beetham trading in St George Gate is in 1787, when he is noted as the landlord of the George & Dragon public house. Joshua had seven children, five sons and two daughters, and when he died in 1798, the business was continued by his fourth son, also called Joshua, born in 1773. The latter will be referred to as Joshua II (seen in the top picture).

The George & Dragon stood adjacent to a coffee shop, owned by Mrs Yeomans, at the St George Gate/Baxter Gate corner. In 1805 the shop was acquired by John Storrs and Joseph Pugh, who used the premises for a wines and spirits business. Pugh died in 1809, though his partner continued the firm alone until his own death in 1826. The property was subsequently acquired by Joshua II, who redeveloped the site and that of the George & Dragon. Thus the Beetham family's association with wines and spirits probably began from 1826, when the George & Dragon was merged with property formerly owned by Storrs and Pugh at the St George Gate/Baxter Gate corner. It is also tempting to suggest that 1826 was the starting date for the dilemma over whether the name of the 'fused' site was the George & Dragon Vaults or just plain Beethams.

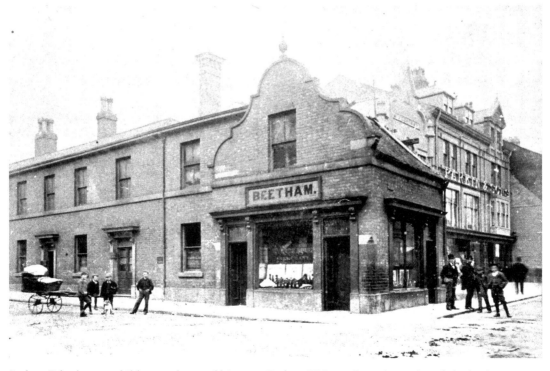

Joshua II had seven children and one of his sons, Joshua III (top picture), continued the business on his father's death in 1846. Joshua III's two sons died when they were young and he took into the business his nephew Michael, born in 1842.

When the Doncaster Corporation began its Baxter Gate widening scheme during the early 1890s, Beethams needed to be set back and rebuilt. Initially, after taking the required strip of land, the Corporation wanted to provide a three-storey building, but after lengthy negotiations a structure with two storeys was erected. In his later years, Joshua III left the running of the business entirely in the hands of his nephew Michael Beetham (*right*). The elder gentleman died, aged 88, at Scarborough in 1906.

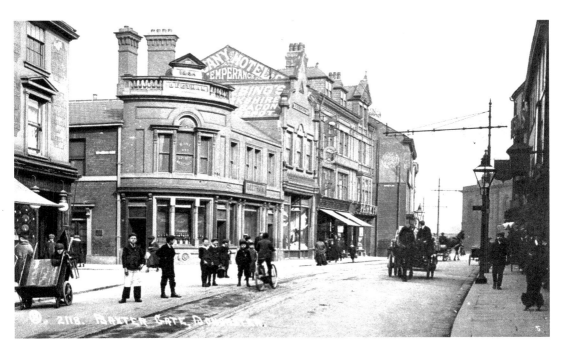

Aspects of life at Beethams during the early part of the twentieth century are recalled in the *Doncaster Chronicle* article (*op. cit.*):

> Everyone knew [Michael Beetham] as a slightly aloof aristocratic man generous to a fault. When there was poverty and unemployment in the area he dipped into his coffers and helped the needy. Market days always found Beethams crowded with farmers and visiting buyers, but the busiest time of all was invariably Race Week ... it was nothing unusual to sell 1,000 gallons of beer during the week.

Michael Beetham died in 1926 and was succeeded by his son John (left), born in 1885. According to notes of his grandson John MaCrae, he had a difficult time, not wanting to carry on the family wines and spirits business at St George Gate; he would have preferred to go to New Zealand like his younger brother. He joined the RNVR in the First World War and fought at the Somme, Beaumont Hamel and Hill 60. He took over the old family wine and spirit business, finally selling out for £36,000 in 1945 to the Wakefield firm of Richard Whitaker & Son. John Beetham died in 1946.

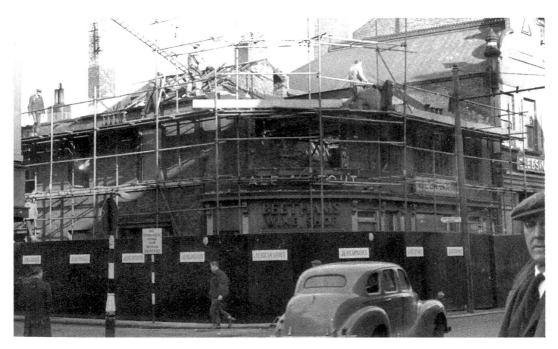

Whitbread Brewery changed the name to The Gatehouse in 1986, thus losing a 200-year association with Beethams.

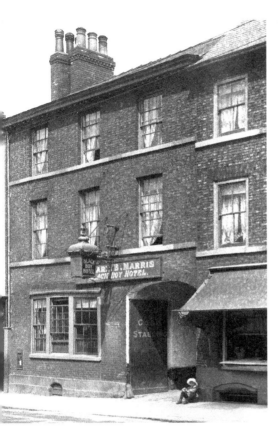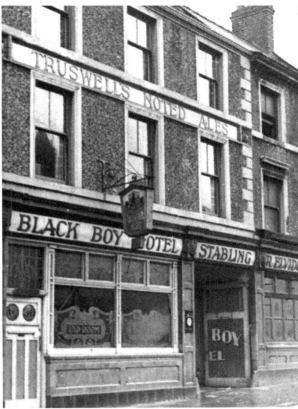

Above left: Hatfield (III: 76) provides us with the earliest located reference to the Black Boy: 1777, with Richard Lambert Pilley, James Whitely, and Truswells Brewery Co. Ltd being listed in subsequent years as owners.

Above right: The French Gate building underwent some alteration *c.* 1922 and was closed *c.* 1959, the *Don. Gaz.* 24 Sept.1959 stating: 'Work will [soon] start on a new traffic scheme. This will mean that the first work will be the demolition of the Black Boy Hotel and part of the Old Barrel Cafe.'

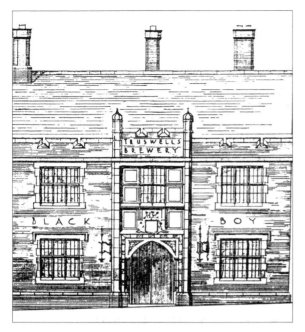

Truswells Brewery Co. Ltd submitted plans on 12 January 1937 to rebuild the Black Boy to the designs of Flockton & Son. The Doncaster Corporation Highways Committee resolved that consideration of the matter be 'adjourned with a view to an alternative site being offered to the company to facilitate carrying out of impending street improvements in the vicinity'. The brewers must have felt disappointed as the pub had prime position on the Great North Road, and a strong, regular clientele. With the projected new road in mind, why didn't the Corporation tell the brewers that there was no possibility of rebuilding or the pub staying in existence? The answer is simply that the proposed new East By-Pass, as it became known, caused much controversy within the Corporation itself as well as with the general public. Obviously events were overtaken by the outbreak of the Second World War, but plans were rekindled shortly after.

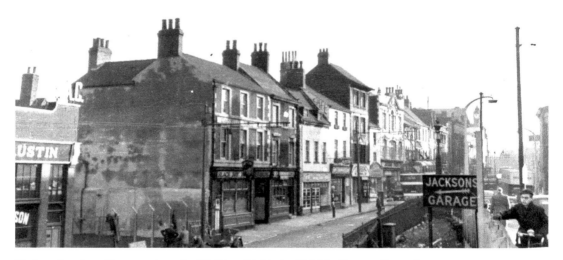

Under a heading, 'Presentation of a Walking Stick', the *D.N.L. Gaz.* 11 Dec. 1835 reports a story concerning the Black Boy:

> On Wednesday evening last, a very handsome and noble looking walking stick was presented to Mr Tymms, chief constable of this town by a number of friends at the Black Boy Inn. The stick is of holly and is most beautifully inlaid on the top with a piece of silver on which is the following inscription: 'Presented to Mr Tymms ... by a few friends, as a token of the respect and esteem'

The stick was acquired by Doncaster Museum and Art Gallery during the 1980s. In a *D.N.L. Gaz.* sale notice of 2 Dec. 1859 it was stated the Black Boy had '15 bedrooms and stabling for 30 horses.'

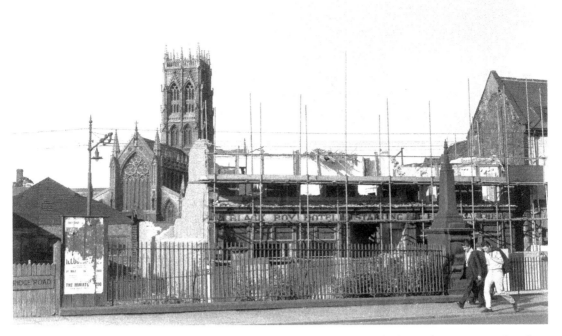

The first stage of the East By-Pass was started in 1960 and the Black Boy became one of its first casualties, seen here being demolished.

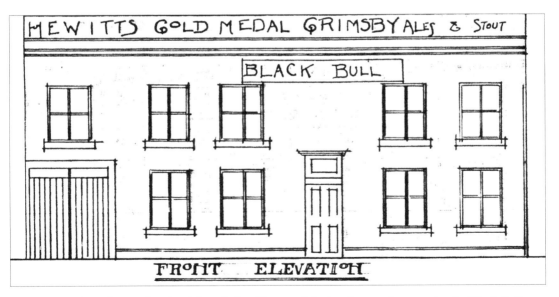

Situated on the north side of the Market Place and dating from at least 1760, the Black Bull was altered c. 1920 and former owners have included William Thompson; Joseph Oliver; Hewitt Bros. The earliest located reference relates to an obituary in the *D.N.L. Gaz.*, 4 May 1810, stating that Mr James Herring had been landlord for fifty years.

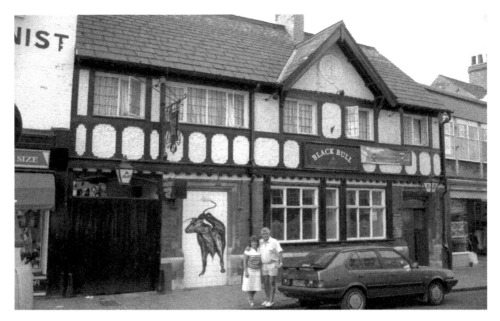

A former landlord of the Black Bull was Alick Jeffrey (29 January 1939 – 22 November 2000), ex-Doncaster Rovers and England under-21 international, seen in the photograph with his wife Sheila in 1989. The *Don. Star* of 20 August 1998 reported that

> [the Black Bull] pub ... has been bought by a London firm wanting to expand into the north of England. The Black Bull in the Market Place closed earlier this year following the retirement of long-standing licensee Alick Jeffrey. It is currently being refurbished by The Old Monk Co. [which] currently has 17 pubs but 13 are in the capital and the Black Bull is their fifth venture outside London.

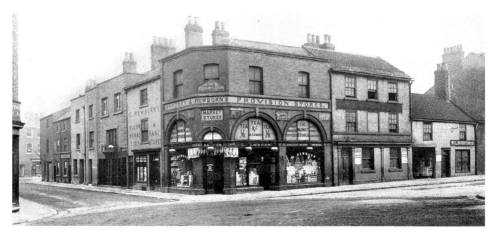

The *D.N.L. Gaz.* of 8 October 1869 provides a reference of 1730 as the earliest date for the Black Swan (second from the right) located on the south side of the Market Place. The inn was conveyed to Doncaster Corporation 1 May 1901, the site being required for the widening of Sunny Bar (correspondence held in D.M.B.C. Legal and Admin Directorate).

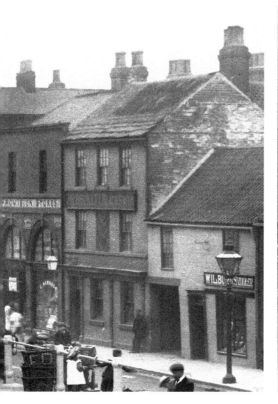
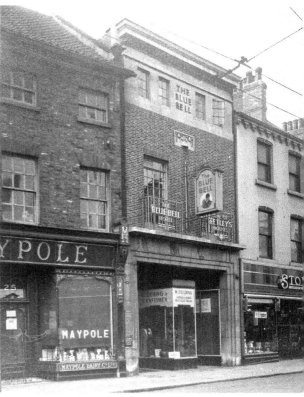

Above left: Following demolition, the Black Swan's full licence was transferred to the Plant Hotel at Hexthorpe. Among the former owners of the Swan were William Booth, timber merchant of Eckington, Derby; George Hague; Doncaster Corporation.

Above right: For many years the Blue Bell, Baxter Gate, was reached from the street via a passage. But interestingly, a small piece in the *Don. Gaz.* of 13 February 1880, states: 'At the beginning of the present century the Blue Bell occupied the whole frontage to Baxter Gate, and consisted of two cosy rooms (placed about two feet above the level of the street) with a passage intervening, the cellaring underneath being occupied as a basket manufactory, by Mr Stephenson, the owner. Eight or nine years later the front was rebuilt, and the Blue Bell was relegated to the back, where it has since remained.' The Blue Bell may be traced to at least 1818 (*D.N.L. Gaz.* April 1818).

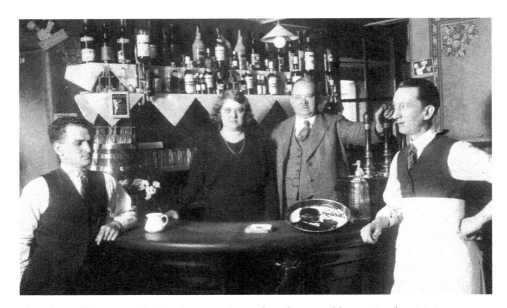

The Blue Bell was wrecked and twenty-four other shops and houses in the vicinity were damaged as a result of an explosion in Baxter Gate during the early morning of Saturday 3 January 1880. The pub was rebuilt in 1880 as a result of the damage and remodelled again in 1931. In subsequent years the pub was renamed Roscoes in 1982, and later The Garden in 1987.

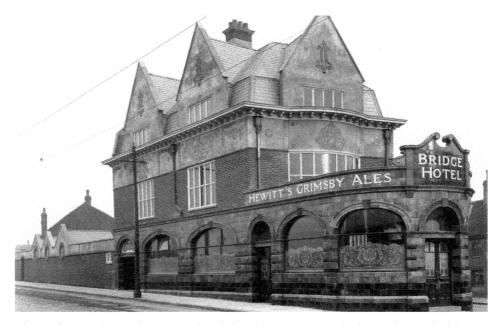

The Bridge Hotel, Marsh Gate, replaced the Labour in Vain, which was demolished for the construction of North Bridge. The plans for the Bridge Hotel, drawn by Hewitt's own architect, were passed in November 1908.

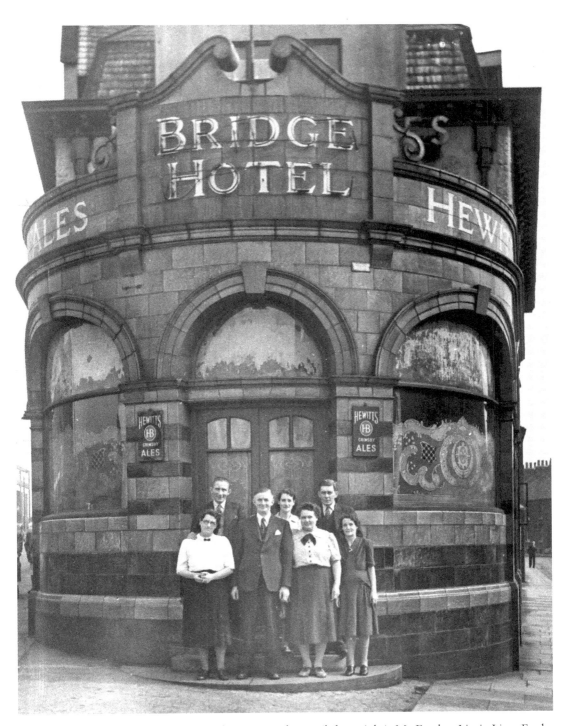

The Bridge Hotel, seen in the mid-1950s. Back row (left to right): Mr Fawley, Lizzie Line, Fred Hathaway. Front row (left to right): Olive Crosby, Stan Williams (landlord), Lucy Williams, Lily Hathaway.

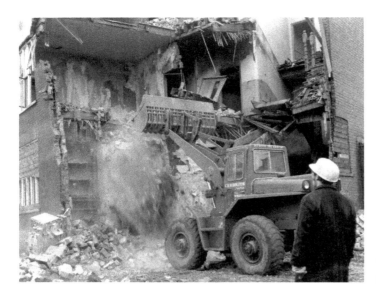

The Bridge Hotel was demolished *c.* 1972.

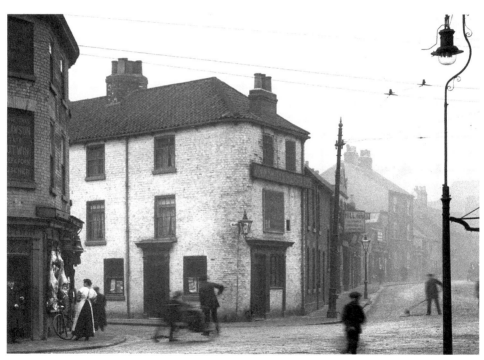

Originally sited at the Silver Street/East Laith Gate corner, the Britannia may be traced to at least 1822 (Baines, *W. Riding Dir.*). Listed among the former owners were Daniel Cook; Joseph Allen; John Smith's Brewery (leased from Doncaster Corporation). On 8 April 1923, when the dead and decomposing body of a newly born male child was found in a drawer in a bedroom of the Britannia, a domestic servant employed at the inn, Nellie Lister, aged 27, was arrested on suspicion of having wilfully murdered her child. Later, the inquest jury, taking advantage of the Infantile Act, returned a verdict of manslaughter.

During the early 1920s it was intended to remove the Britannia to facilitate street improvements and the Corporation Minutes on 1 Aug. 1922 read: 'Recommended that 6 months notice be given to John Smiths to terminate tenancy of Britannia Inn.' An earlier attempt by Mappins in 1921 to acquire and transfer the license to a site in Wheatley had failed. So it was eventually authorised for the Barnsley Brewery Co. to acquire a site at Balby from the Corporation and transfer the licence there. The *Don. Chron.* of 11 April 1924 carried an article about Balby's new hotel yet from mentions in the corporation minutes, the Britannia building in Doncaster seems to have remained standing until around 1926/27. The *Don. Chron.* of 7 March 1924 notes that the Bench agreed to terms of licence along with the surrender of the Boot & Shoe licence.

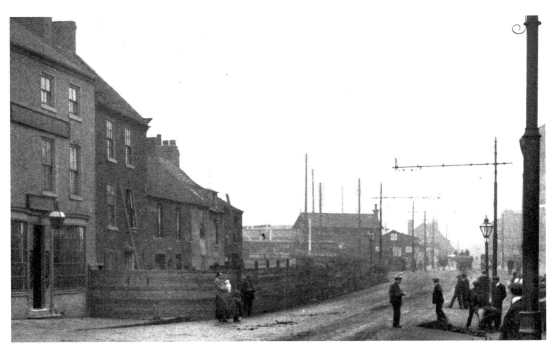

During the early nineteenth century, a site in French Gate/Marsh Gate once occupied by the Doncaster Letter Office became the Doncaster Arms. In 1816 however, the owner was declared bankrupt. The name of the house was later taken for a new hotel which opened in Bennetthorpe (becoming known as the Earl of Doncaster Arms). The old Doncaster Arms reopened as the Brown Cow. (Tuffrey and Day, 1984) and the earliest reference to the latter is 1821, when it opened (*D.N.L. Gaz.* 30 Nov. 1821).

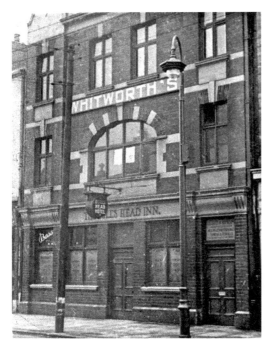

Dating from at least 1780 (Hatfield III: 92), the Bull's Head, St Sepulchre Gate, was altered in 1912 by Whitworth, Son & Nephew and in 1987 was renamed Oscars' (*Don. Free Press* 10 December 1987), and then Paris Gate, May 1997.

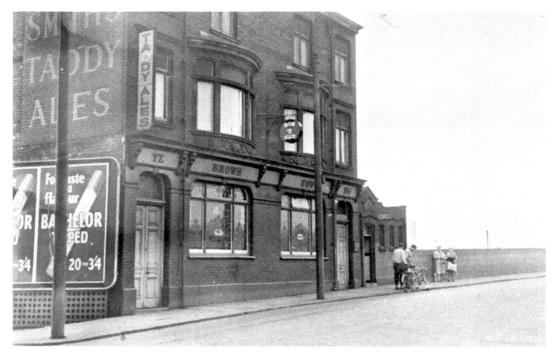

The Brown Cow was demolished for the North Bridge construction *c.* 1908 and a new pub was built to the designs of John Athron on a site nearby. Samuel Smiths leased the new property from Doncaster Corporation and it was demolished in 1964 (*Yorks. E. Post* 27 August 1964).

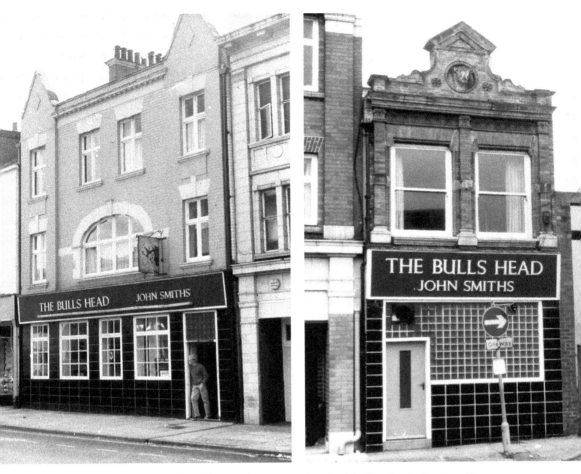

Above left: At one time the Bull's Head was associated with Woodcock family of boxers.

Above right: The entrance from West Laithe Gate to the Bull's Head.

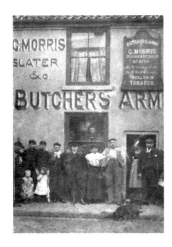

The Butcher's Arms was a small beer house in Marsh Gate dating from at least 1852 (*D.N.L. Gaz.* 27 Feb. 1852). Among the former owners were Thomas Smirthwaite and James Milnthorpe before the licence was refused in 1906 (*Don. Gaz.* 8 June 1906), although it seems to have struggled on until 1907 (*Don. Chron.* 7 June 1907).

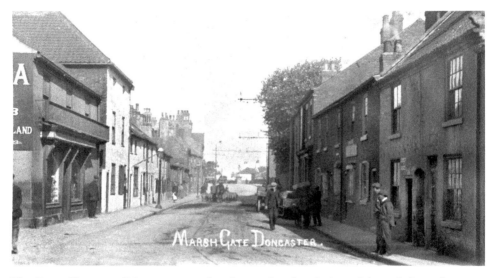

The *Don. Chron.* 16 Feb 1906 quoted an interesting description of the pub from the Brewster Sessions:

> The Butchers' Arms was entered by a door two foot four inches wide. The front room was eleven feet wide across the frontage, and eleven feet deep; it was eight feet one inch in height, and it was lighted by a single window four feet six inches by three feet. The stairs were boxed from the corner of it. Proceeding from the front room, the living room was in the rear, and the latter room was eleven feet three inches wide, by seven feet deep, and eight feet one inch high. Upon the first ground floor there was a bar at the back, fourteen feet four inches wide across the front by seven feet three inches deep and more than half of that was taken up by a fixed counter. With the exception of a wooden stool there was no seating accommodation … The bar was further up the Butchers' Arms Yard …

A discussion had proceded over the number of licensed premises in Marsh Gate in relation to the drinkers frequenting them and consequently the Mayor said: 'The Justices had decided to refer the house for compensation on the grounds of non necessity and structural unfitness.'

CAMELOTS - GREYHOUND

The Old Trinity Presbyterian Church, which opened on 14 August 1892, was converted for use as a pub, Camelots, and started trading 26 April 1982. It was the first pub to open its doors in Wood Street since the Wood Street Hotel closed in the mid-1920s. The Camelots name was changed to Esque in 1995 (*Don. Star* 8 August 1995), and then Eden. It was stripped of its licence in January 2008.

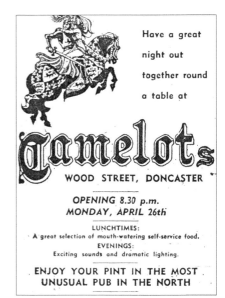

Left:
Preparations for
Halloween night
in Camelots
during 1989.

Right: Opening
advert for
Camelots.

Have a great
night out
together round
a table at

Camelots

WOOD STREET, DONCASTER

OPENING 8.30 p.m.
MONDAY, APRIL 26th

LUNCHTIMES:
A great selection of mouth-watering self-service food.
EVENINGS:
Exciting sounds and dramatic lighting.

ENJOY YOUR PINT IN THE MOST
UNUSUAL PUB IN THE NORTH

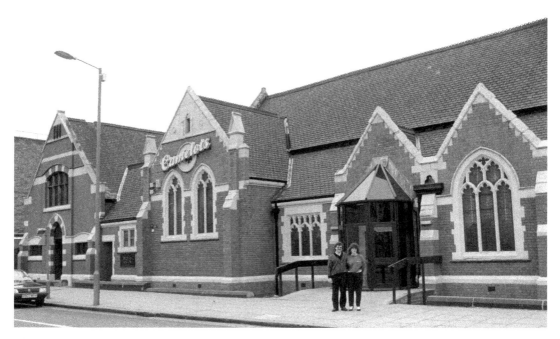

The *Don. E. Post* of 26 April 1982 noted the following on the opening of Camelots:

apart from a smart new entrance with the 'Camelots' sign above, the exterior is unaltered. Inside, however, a figure in excess of £100,000 has been spent in conversion and renovation work. Main features of the original interior, such as the high roof, the windows, the organ and much of the woodwork, have been retained and the rest of the decor is designed to be in keeping with the original. 'In no way did we want it to be a desecration,' explained Mr A. Goodison, retail development manager for the brewers, Whitbread.

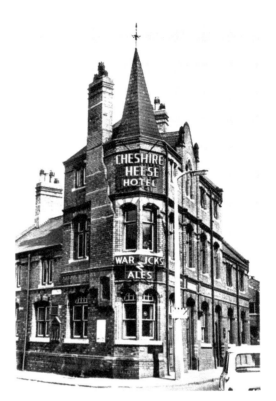

Located on Wheatley Lane, the Cheshire Cheese harks back to at least 1821 (Hatfield III: 81). It was rebuilt in 1888 and altered in 1913 and 1964, the work including the removal of the spire and steeple. Past owners have included Joseph Parkinson and Warwicks & Richardson.

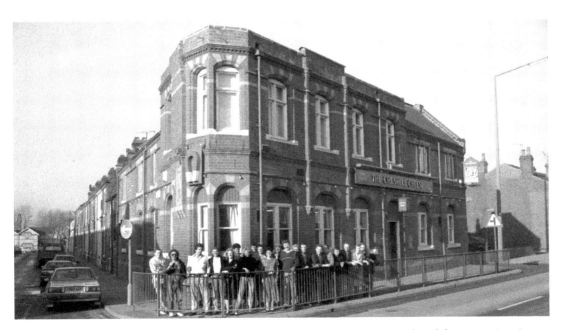

Locals pose outside the Cheshire Cheese in 1989. The premises were closed for some time in 2000, 2001 and 2003.

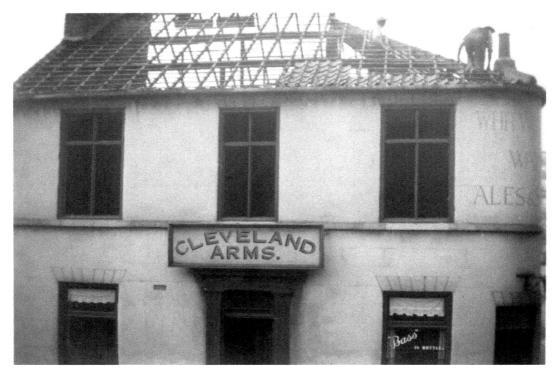

The Cleveland Arms existed at the corner of Duke Street/Cleveland Street from at least 1852 (*Don Chron.* 17 Dec. 1852). It was rebuilt in 1939 and listed among its previous owners were Timothy Lindley and Whitworth, Son & Nephew.

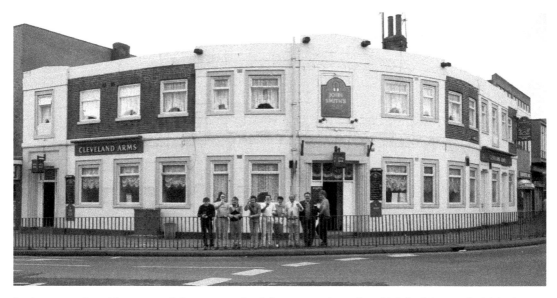

In August 1986 a blaze caused £3,000 worth of damage to the pub, which had been refurbished only months earlier. The pub's name was changed to the Emporium in January 1997.

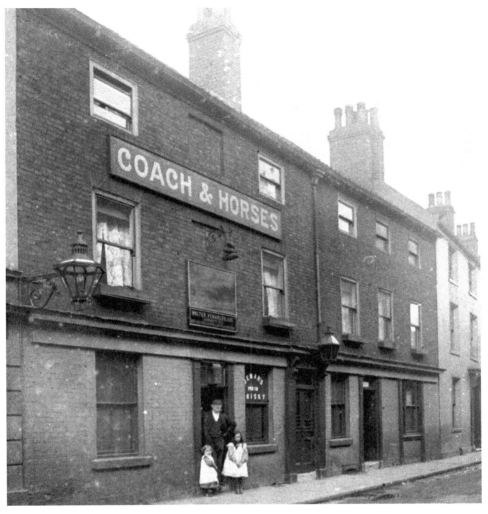

A chronology of former Coach & Horses' licensee Hettie Pascall's life in the licensed trade appeared in the *Don. Star,* 18 Feb. 1996:

> Born into the licensing trade, Mrs Hetty Pascall who was former licensee of the Green Dragon, French Gate until she retired in 1961 ... announced she was back in the trade during February 1962. She and her husband Norman had become licensees of the Coach & Horses Scot Lane. Mrs Pascall was born in St James's Tavern which was kept by her parents, Mr and Mrs Oliver. Later they moved to the Thatched House and Green Dragon. Mrs Pascall, who had been married twice was at the Alma Doncaster, from 1945 to 1951, the Crown & Anchor at Gainsborough and the Elephant Hotel Barnsley until she joined her mother at the Green Dragon in 1954.

The earliest date for the Coach & Horses, Scot Lane is 1780 (Hatfield III: 87). Hatfield's reference mentions that the premises belonged to the town council and let on a lease of 25 March 1780 for ninety-nine years. The *Don. Chron.* of 4 June 1915 mentions that the 'demolition of the Coach & Horses Inn, in connection with the scheme for widening Scot Lane has commenced.'

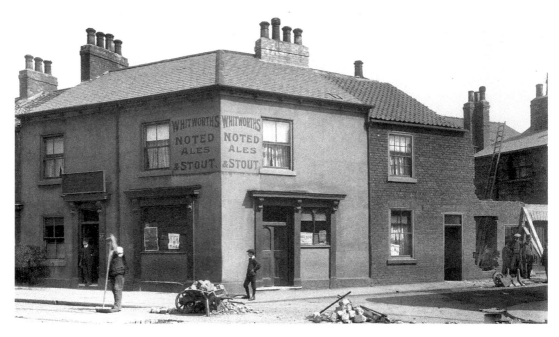

The Corner Pin in St Sepulchre Gate West was altered in 1909, the *Don. Gaz.* 5 March 1909 reporting the following from the Adjourned Brewster Sessions:

> Mr Allen, on behalf of Messrs Whitworth, Son & Nephew submitted plans for alterations to the Corner Pin in St Sepulchre Gate. The Plans were prepared by Mr J. Athron. They include the taking down of an old cottage, the provision of stabling accommodation, the taking down of a boundary wall and other improvements. – The Plans were passed.

It is likely that the pub dates from at least 1834 as a reference in the *D.N.L. Gaz.*, 31 August 1855, mentions Richard Earnshaw occupying a beerhouse opposite the Horse & Jockey for twenty-one years. Among the former owners were Joseph Earnshaw; Thomas Windle; Whitworth, Son & Nephew. The premises were refurbished in 2000.

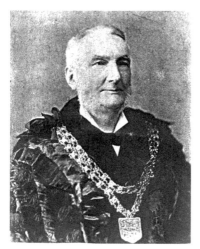

The Corporation Brewery was situated in Corporation Street at the rear of the Corporation Brewery Taps. A brewery was established on this site around 1855 by Johanthan Cooke. After Cooke's death in 1864, his wife announced that she was to continue running the business. But she appears to have leased it in 1871, to William Wrightson Harrison. This was until 1885 when Alfred Ream, (pictured left) born in 1831, and of King's Lynn, paid her £2,550 and took control. In the sale notice in the *D.N.L. Gaz.* 9 Jan. 1885 details of the brewery at that time were given: 'The trade of the Brewery, which is upwards of 3,000 barrels per annum, may be greatly extended ... The Brewery business, which was established in 1855, is now being successfully conducted.'

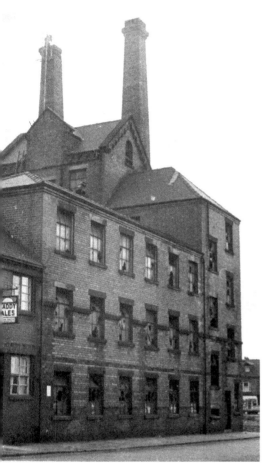
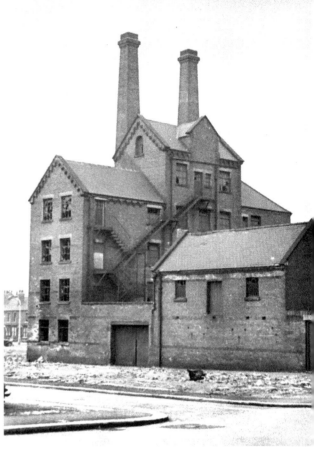

Above left: Ream was no stranger to the liquor trade since he had a wine and spirits business in King's Lynn. The Corporation Brewery was managed by one of Alfred's sons, Charles Alfred Ream, and it was rebuilt in 1891. The design work was undertaken by the Manchester Company Gregory Haynes, Brewer's Architects, engineers and mechanics. The construction work was carried out by Doncaster builders H. Arnold & Son.

Above right: On the first day of operations at the new brewery Charles Ream nearly came to an untimely end. The *Don. Gaz.* of 18 December 1891 reports that 'the left side of his coat got entangled in some cog wheels ... If the driving wheel had not come off he would have been killed.' In 1895, Charles Ream purchased Moor Cottage, a quaint little detached house in Hall gate, Doncaster, and he made this his family home. He is shown on page forty in the cottage's rear gardens. Near the close of the nineteenth century, the pubs tied to the brewery included the Malt Shovel in St Sepulchre Gate; Bay Horse, French Gate; Blue Bell, Baxter Gate; King's Arms, St Sepulchre Gate; Fitzwilliam Arms, Fitzwilliam Street and of course the Corporation Brewery Taps at the Cleveland Street/Corporation Street corner.

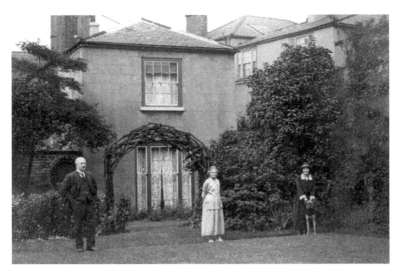

In 1900 the firm ceased to trade under Alfred Ream & Son in favour of Ream & Son. Alfred Ream died in 1914 and his son retired from the brewery business four years later, leasing the Corporation Brewery to Wheatley & Son. However, this was short-lived, as the brewery was sold in February 1925 to Samuel Smith's for £6,000. Curiously, the latter did not continue brewing operations, and around 1928 the building was converted into a common lodging house, providing a total of ninety-five beds. Charles Ream died in 1948 and his brewery continued as a lodging house until closure in 1955. Five years later it was obtained by Doncaster Corporation, under the Central Area No. 1 Compulsory Purchase Order and subsequently demolished for the high-rise flats to be built.

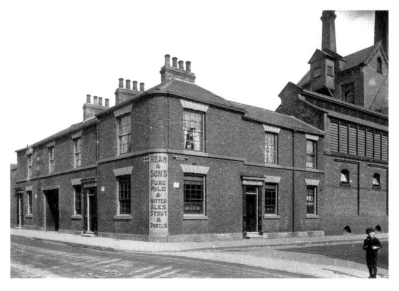

The Corporation Brewery Taps may be traced to at least 1855 (*D.N.L. Gaz.* 1 September 1885) and was rebuilt in 1934 following fire damage. Jonathan Cooke and Alfred Ream & Son were past owners.

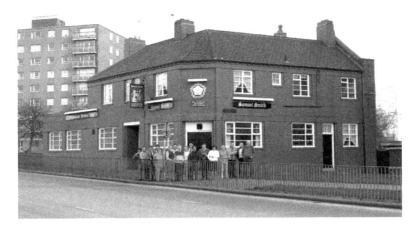

A memory of the Corporation Taps fire appeared in the *Don. Star,* 12 March 1998:

> When the Corporation Taps in Cleveland Street caught fire in the early hours of Tuesday morning, 12 March 1934, it was initially thought that the occupants were sleeping in the blazing building. The flames soon had a firm grip on the building and, despite the efforts of Doncaster Fire Brigade, most of the rooms were gutted. The tenants of the pub were Mr and Mrs Watkinson, who with Mrs Watkinson's brother, Fred Reville, were out for the evening. A member of the Fire Brigade told the Press that the fire was believed to have started in a downstairs room which had walls lined with match boarding. When the fire brigade reached the scene the flames were reaching half-way across the street. Adjoining the pub was public lodging house (formerly the Corporation Brewery) in which 60 or 70 people were sleeping.

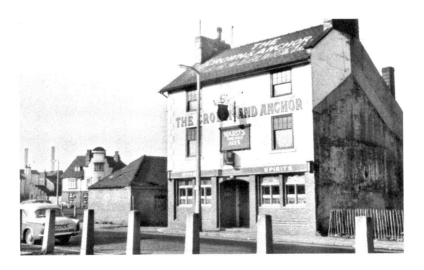

Before taking the Crown & Anchor title, this pub, in Friendly Street, may have been known as the New Crown and Old Wagon (information held in D.M.B.C. Legal & Admin. Dept). The name Crown & Anchor may be traced to 1807 (*D.N.L. Gaz.* 23 January 1807). Messrs S. H. Ward rebuilt the premises in 1908; the owners prior to Wards included Joseph Bradley's Soho Brewery Co. Ltd.

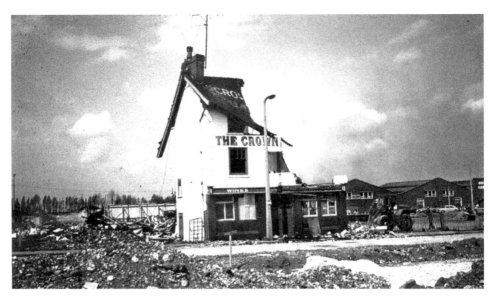

The Crown & Anchor was conveyed to Doncaster Corporation on 15 May 1972 and later demolished for road improvements.

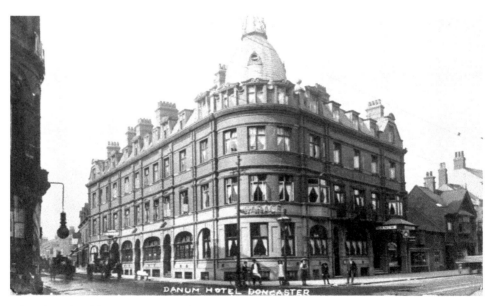

After the sale of the Ram in 1907 the Sanitary Committee on 28 January 1908 approved a 'plan of [the] proposed St Leger Hotel and lock-up shops at the High Street/Cleveland Street corner for the Planet Trading Co Ltd'. The reference to the new premises being titled the St Leger Hotel is interesting and puzzling because it never retained that name. At the local Brewster sessions held in February 1908, the plan for the new building was submitted to the justices by Frank Allen on behalf of the owners. He acknowledged that 'if the owners desired to alter the name of the premises they must make a special application to the justices'. Seemingly this is what occurred in subsequent months, and the name Danum was adopted.

The Danum Hotel was designed by architect W. H. Wagstaffe of Chesterfield and Cleveland Street, Doncaster. On 27 August 1909 the *Don. Gaz.* announced:

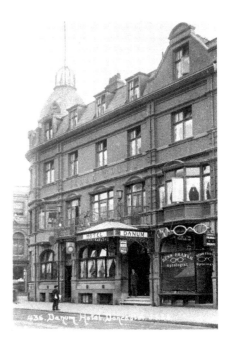

The hotel will be open for receiving visitors on 1 September or thereabouts. The contractors for the whole of the buildings are Messrs Wm Thornton & Son, Rotherham. The stone is from Mansfield and the Empire Stone Co., Narbrough, Leicester and the pressed bricks from Accrington. The roofs are covered with the Buttermere Co's Westmoreland green slates. The furnishings and decorative work was executed by Messrs Sheard, Binnington Co of Doncaster and W. Cockayne Sheffield, and Eyre & Sons, Chesterfield.

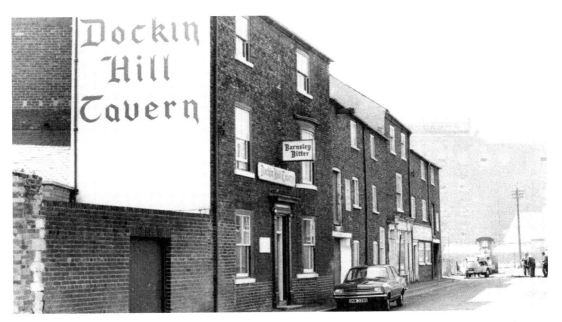

1858 (Slater, *Lincs., Notts., Rutland and Yorks. Dir*) is the earliest date found for the Dockin Hill Tavern, situated in Lower Fisher Gate. In a sale notice in the *D.N.L. Gaz.*, 4 Aug. 1876, it is mentioned that the pub was erected 'many years ago by the late Luke Naylor.' Among the other owners were William Robinson; George William Morris; New Trent Brewery Co. Ltd. A full licence for the premises was granted in 1949 (*Don. Chron.* 14 April 1949). The pub closed on 7 February 1971 (*Don. E. Post* 6 February 1971) and was subsequently demolished to make way for work on the East By-Pass.

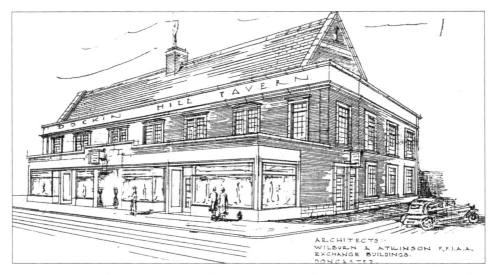

On 28 May 1935 the Corporation's Highways Committee adjourned a decision on the Barnsley Brewery Co's proposal for rebuilding the Dockin Hill Tavern to obtain further information. Three years later the plans were submitted again and the committee recommended that they were 'approved but the company be requested to confer with the borough surveyor before works commenced'. Significantly at the same meeting the committee also resolved that: 'The borough surveyor be instructed to submit tentative plans for development of the area in the vicinity of proposed road from French Gate to Wheatley.' From the brewery's point of view this was surely ominous and discouraging, particularly as it had employed top architects Wilburn & Atkinson to produce the designs for the new Dockin Hill Tavern.

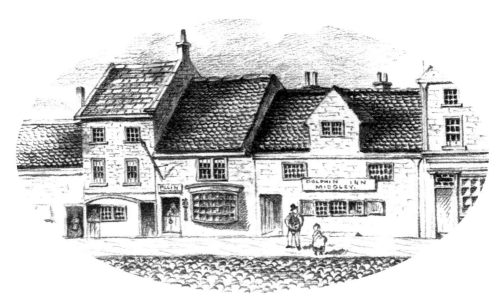

The Dolphin, situated in the west side of the Market Place, ceased trading in 1892 (*D.N.L. Gaz.* 22 Jan. 1892) having been in existence from at least 1781 (Hatfield II: 328). Among the past owners were Thomas Crookes; Doncaster Corporation; George Boothman.

The Steward's cash book (1805-10): 1806, p. 27 (D.M.B.C. Archives Dept) provides a date of 1806 as the earliest found reference to the Duke of York in French Gate. The building was altered to the designs of Dennis Gill & Son in 1920 under the direction of brewers Hewitts (as lessees). Past owners included Robert Browser. The *Don. Gaz.* of 18 April 1957 carried a heading 'More Hotels to Go in £150,000 Stores Deals' and gave the following information about the Duke of York: 'The Duke of York closes on Easter Monday and it is understood that it has been bought by the Leeds tailoring firm of Messrs Peter Peck Ltd. Work is expected to begin on the conversion of these premises in June but the landlady for the past nine years Kathleen Clark moves out at Easter to take a hotel in Castleford.'

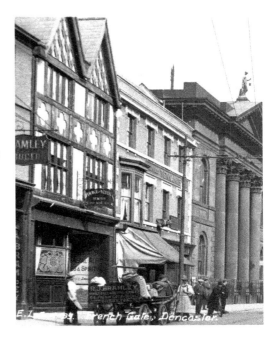

The Earl of Doncaster Arms was built in 1816 (*D.N.L. Gaz.* 13 September 1816). The *Don. Gaz.*, 22 May 1903, adds these details:

At the Borough Court on Monday, plans were produced by Mr H. Athron, architect, for the alteration of the Doncaster Arms, the proposal being to put bay windows in the smoke-room and bedroom above. There were no inside alterations ... The house was built by Mr John Cooper, slater, and was opened on 10 April 1818 under the title of The Earl of Doncaster Arms. In September 1828 the title was changed to the Doncaster Arms and Turf Hotel, and on 20th May 1843, it was altered to the Doncaster Arms. It was now proposed to alter it back to the original title The Earl of Doncaster Arms.

Among the former owners of the Earl were William Broughton; William Cotterell Clark; New Trent Brewery Co. Ltd; Barnsley Brewery Co. Ltd; Anchor Hotels; John Smiths; Trust House Forte; and Crown Hotels Ltd. The pub was rebuilt in the 1930s and carried the name of the Acorn for a period. The name changed back to Earl of Doncaster in 1973 (*Don. E.P.* 5 November 1973).

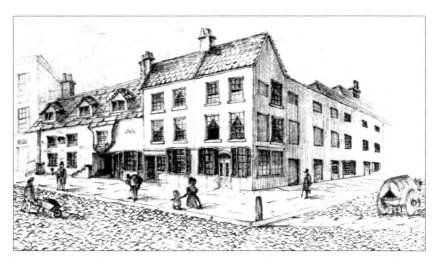

An Elephant Inn existed in Doncaster's High Street – on the site currently occupied by the Nat West Bank – from at least 1763 (Hatfield: III). Little detailed information exists about the inn during the mid-eighteenth century, but we may assume that it served the coaching trade on the Great North Road. A glance over the extent of the premises may support this, as it included two dining rooms, sitting room, bar, large kitchen and back kitchen, two cellars and lodging rooms which contained twenty-four beds. To the house were attached granaries, stabling and sheds for sixty horses; also a small shop fronting the street. Hatfield notes a meeting of the Freemasons at the inn during 1788 and interestingly mentions 'the Elephant Inn – an old fashioned hostelry built in the reign of Elizabeth...' The inn closed in 1829 and was purchased by the banking firm of Sir William B. Cooke and was demolished shortly afterwards.

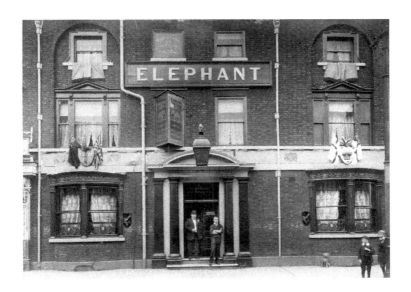

The Elephant sign was not seen again in Doncaster until 1850, when John Elwiss, a local timber merchant who had saw mills in Marsh Gate, opened premises with this name on the south side of St Sepulchre Gate. The new Elephant occupied premises which were built in 1781 and had been the home of John Jarratt, the founder of Christ Church, Doncaster. The inn's owners during the latter half of the nineteenth century were Mary Fisher, Mary Slayter and the Worksop & Retford Brewery Co. Ltd. One of the inn's most celebrated landlords was Henry Bunting (seen on the left in the doorway). He started at the Elephant in 1909, was a Freemason and his tenancy spanned the inn's rebuilding, which took place in 1915 as a result of the St Sepulchre Gate widening scheme.

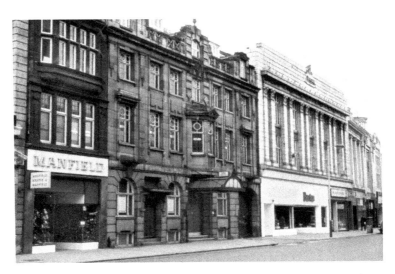

The new hotel was designed in what can only be described as 'free-style' and was undertaken by one of Hewitt's own architects. The rebuilt Elephant was destined to have a mere sixty-year lifespan and was sold by Crest Hotels in 1974. After a short existence as a furniture store under the ownership of Hardy & Co (Furnishers) Ltd, it was demolished.

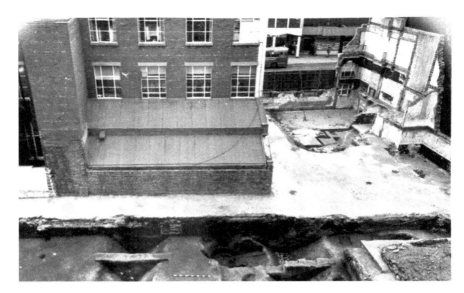

Following the Elephant's demise, an archaeological dig on the site (viewed here from Priory Place) revealed some interesting finds, and among these were several Roman ditches, a fourth-century pot containing a number of coins, and a rare medieval jug.

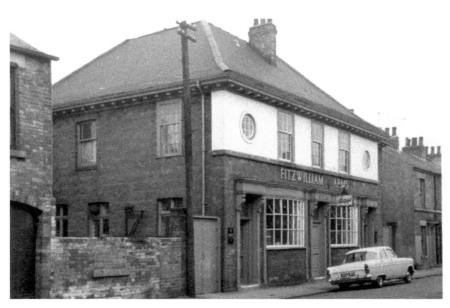

The *D.N.L. Gaz.,* 12 November 1867, notes that 'W. & N. Nettleton, brewers Fitzwilliam St, took out a licence for selling beer on premises.' But it is unclear whether this is the Fitzwilliam Arms' opening date. The first time the name Fitzwilliam Arms, Fitzwilliam Street has been located is 1870 (*D.N.L. Gaz.* 18 February 1870). The pub was formerly attached to the Crown Brewery and rebuilt in 1925. The premises were granted a full licence in 1949 (*Don. Chron.* 14 April 1949). Among the past owners were Alfred Ream & Son, Bass, Ratcliffe & Gretton.

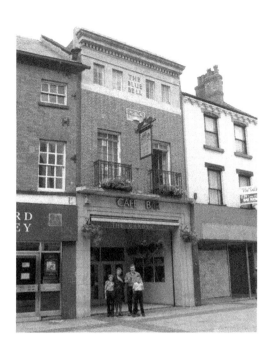

The Garden, Baxter Gate, opened during 1987 (*Don. Free Press* 17 Dec. 1987). It was formerly titled Blue Bell and Roscoes', the premises became Wently's Hamburgers in May 1997 and McDonalds in June 1999.

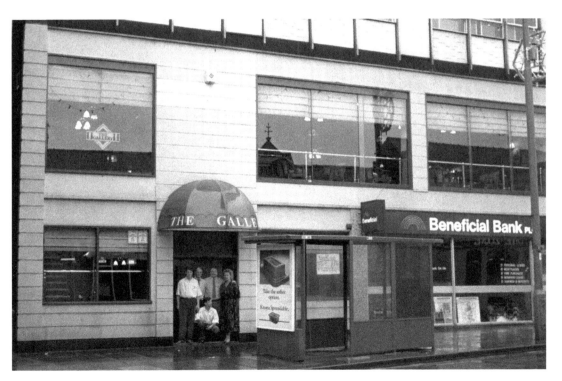

The Gallery in Silver Street opened on 13 April 1988 (*Don. Free Press* 14 April 1988) and was created from the shell of the old Yorkshireman public house (ref. as above). The pub closed in 1997 and has since been renamed Tryst.

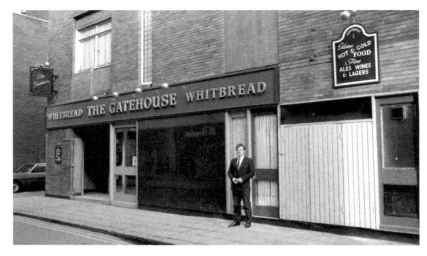

The Gatehouse, St George Gate, occupied the old Beethams premises and was opened on 24 July 1986 by Whitbread East Pennines Ltd. Landlord Ronald Macrae is pictured outside. The premises were retitled Mayfair and Olivers in October 1997, and D'arcy's in 2004.

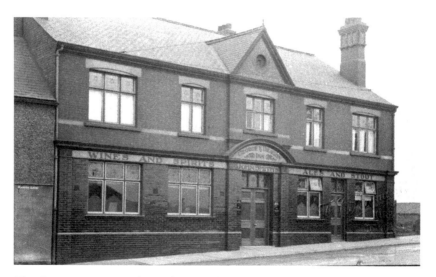

The George & Dragon, located in Marsh Gate, existed from at least 1755 as the Pack Horse but according to a deed of 1772 (Held in D.M.B.C. Legal and Admin. Directorate): 'The 'Pack Horse' was recently pulled down and rebuilt as the 'George & Dragon'. Plans were passed for the rebuilding of the pub in January 1903 but permission by the Licensing Magistrates was not given until 1906, the *Don. Chron.* 16 Feb. 1906 adding: '... Mr John Athron, architect and surveyor, Doncaster, produced the plans ... It was proposed to set back the premises three feet six inches – The application was granted.' The George & Dragon was demolished during the Autumn of 1956 (*Don. Gaz.* 27 September 1956). Among its owners were Samuel Lewis; John Spurr and William Rhodes; William Tinkler and Mathew Cook; Samuel Spur; John Smith's Brewery.

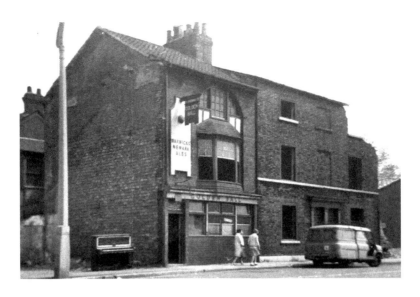

A Golden Ball existed in Factory Lane (Golden Street) until 1810. The pub is first located in Spring Gardens during 1820 (*D.N.L. Gaz.* 25 August 1820). The *D.N.L. Gaz.* of 8 Sept 1820 gives notice of a sale of the estate of John Chester, lately bankrupt: 'Lot 4 Reversionary and other interests of the said Bankrupt ... newly built public house in Spring Gardens Doncaster called the sign of the Golden Ball in the occupation of Mr John Glossop, tenant on lease ... 8 years unexpired ... yearly rent of £23.' The *D.N.L. Gaz.* 22 July 1889 recorded that Frank Weaver, licence holder of the Golden Ball, was convicted of '1. Permitting his premises to be the habitual resort of prostitutes, 2. Attempting to bribe Police.'

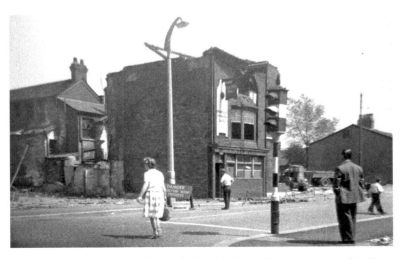

Proposals for the alteration of the front of the Golden Ball were approved in November 1963 for Warwicks & Richardsons Ltd. Included in the list of past owners were John Chester; Arthur Joseph Smith; A. M. Eadon & Co. Ltd; Warwicks & Richardsons Ltd. Correspondence held in the D.M.B.C. Legal and Admin. Directorate states that the council acquired this site in 1963 for part of the 'Golden Acres' development, and affected entry to the inn on 5 June of that year.

The Golden Barrel, French Gate, was the birthplace of John Francis Bentley (1839-1902) architect of Westminster Cathedral. The premises may be traced to at least 1813 (*D.N.L. Gaz.* 13 Sept 1813), the reference relating to the occupancy of the Dey family and the previous owners included Charles Dey; the Bentley family; James Milnthorpe (*Don. Chron.* 11 Aug. 1922), Hay & Son. The licence lapsed on 8 January 1937 (*Don. Gaz.* 11 Feb. 1937) and the premises were converted to Ye Olde Barrel Cafe. The building was demolished in the early 1960s to facilitate road improvements in the area.

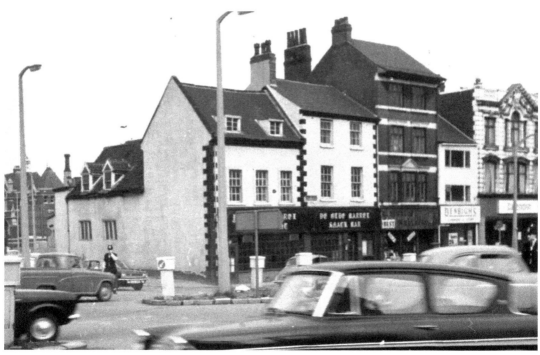

Present Elevation

A deed held in D.M.B.C. Legal and Admin. Directorate states the Golden Lion in Cleveland Street was erected between 1812-18. The first located mention of the name Golden Lion is 19 Sept 1818 (*op. cit.*). A 'To Let' notice, which appeared in the *D.N.L. Gaz.* 22 Dec. 1826, mentioned the pub comprised: 'Good sitting and bedroom, bar and kitchen, excellent cellars and brewhouse, spacious yard and stable a convenient out-offices, with an extensive garden stocked with select fruit trees, summer house etc. The premises are entire, in thorough repair, replete with fixtures, and well furnished, and supplied with spring and soft water.' In 1880 Cornelius Wilson was convicted of permitting gaming on premises.

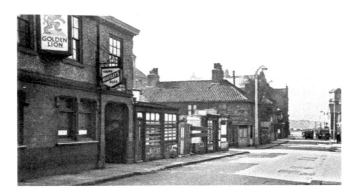

Plans for the proposed alterations and new front were approved for Hartley's Brewery during October 1908. On 11 May 1909 permission was given to 'erect [a] hoarding on the footpath in front of the Golden Lion for 14 days during repairs to the building'. An objection was taken to the renewal of the licence of the Golden Lion on Monday 6 March 1922, on account of ill conduct. In the opinion of the police it was the worst house in the borough. After much deliberation the licence was refused, but was subsequently renewed at a later date. The former owners included John Alexander; Arthur Joseph Smith; Samuel Beastall; Brookhill Brewery Co. Ltd; Hartleys Brewery. The pub ceased trading on 9 April 1961, being compulsorily acquired by Doncaster Corporation and the compensation given was £9,500. It was demolished on 28 April 1961.

PRESENT ELEVATION

The earliest located reference for the Good Woman in St Sepulchre Gate is 1793 (Hatfield III: 77) though it was formerly titled Wheatsheaf, and Quiet Woman. The idea of a Labour Party was born in the Good Woman. This was after a resolution had been passed by the Trades Union Congress in 1899, and a conference of trades union and socialist bodies at the Memorial Hall, Farrington Street, London, set up the Labour Representative Committee to establish a distinct Labour Group in Parliament. In 1906 that committee was to become known as the Labour Party. The motion that confirmed this at the 1899 TUC Conference in Plymouth came from the old Amalgamated Society of Railway Servants, from which emerged the NUR. It was the Doncaster branch, meeting at the Good Woman, that had forwarded the resolution passed at the society's annual conference a few months earlier.

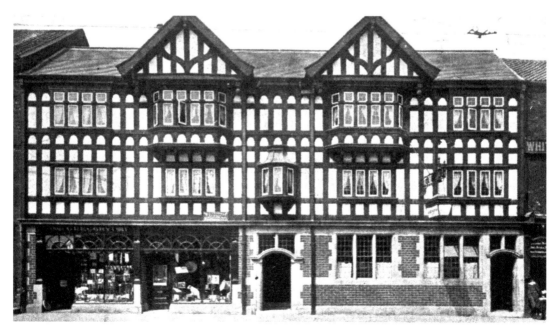

Plans were passed for alterations at the pub in 1899 for J. Fox & Son (architect J. Furnival) and in 1911 for J. Fox & Son (architect W. J. Tennant). The licence was refused in 1938 (*Don. Chron.* 5 May 1938) and for a period it became a transport cafe.

A Green Dragon pub existed in the High Street until 1832 (*D.N.L. Gaz.* 16 March 1832). These premises were later occupied by Carter-Longbottom's ironmongery business. The first located reference to the French Gate Green Dragon is in 1833 (*D.N.L. Gaz.* 4 Jan. 1833). The *Don. Gaz.*, 17 Sept. 1897, noted that the Green Dragon, 'property of Mr H. Dobrah has been sold to Messrs Tennant Bros, brewers, Sheffield, £6,300'. Plans were passed to renovate the premises in 1899. The Green Dragon closed on Thursday 19 Jan. 1961 (*Don. Gaz.* 26 Jan. 1961). A week later the same newspaper reported: 'For regulars who called in at the Dragon for their last pint on Thursday night it turned out to be a "bottles only" evening. The supplies of draught beer had run out.'

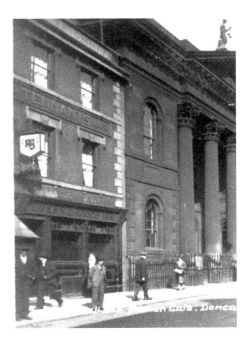

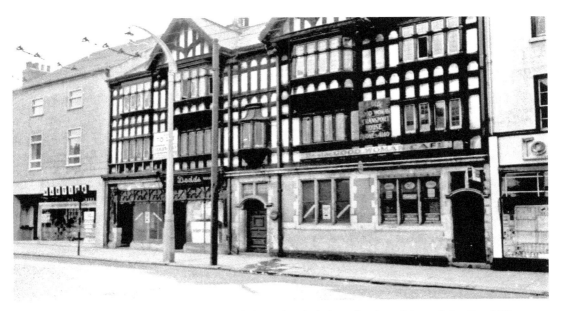

The *Don. Gaz.*, 19 May 1960, offered these details before the demolition of the Good Woman cafe:

> Three shops and Good Woman one time a public house are up for sale. The Good Woman was closed as a public house just before the last war and troops were billeted there. Afterwards it became a transport cafe ... the cafe has been closed for about a year.

Listed among the past owners were Samuel Johnson & Son and J. Fox & Son.

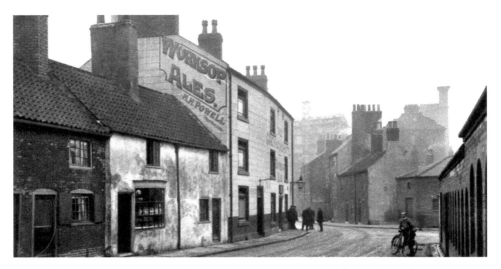

It is probable that an earlier inn, The Wagon, occupied the site of the Greyhound in High Fisher Gate. An assessment of 1782 states that it was owned by Mr Thos Botterill and occupied by Mrs Watson, the premises being described as 'House, stables, garden and stack yard' (Hatfield III: 63). The earliest located reference to the Greyhound is 1822 provided in Baines, *W. Riding Dir.* Included in the list of owners were Joseph Garside and Worksop & Retford Brewery Co. Ltd. The pub closed on 31 December 1961, the site being required for the construction of the East By-Pass (correspondence held in D.M.B.C. Legal and Admin. Directorate).

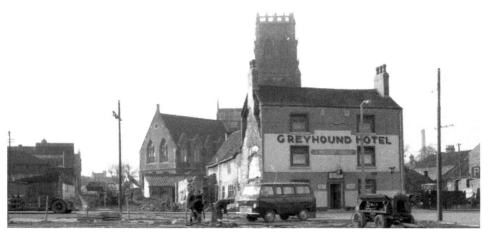

The *Don. Chron.* of 16 August 1962 carried a short piece headed 'The old Greyhound is being demolished':

> Many are the deals that farmers and cattle men have clinched in the low-roofed bars of the old Greyhound Hotel, one of the oldest public houses in Doncaster which is now being demolished to make way for an improvement to the junction of the newly completed section of the Doncaster east-west By-Pass road with High Fisher Gate. The Greyhound [was] one of a number in the Market Place area to be granted extra opening hours on Market days ... In recent years 'mine-host' at the Greyhound has been, Mr George Knapton, but previously for many years, it was run by members of the Smith family

CHAPTER 3

HALLCROSS – OLD GEORGE

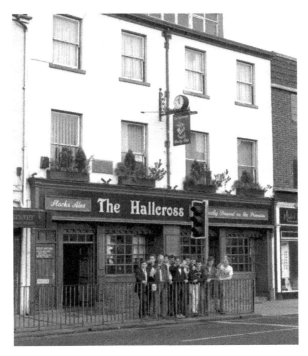

One of the region's leading local bakers and confectioners, Coopland's, is well-known throughout the area and for a time they ventured into the licensed trade. 'It all began back in the late 1970s,' explained Coopland's director William McIlroy, adding:

> For several reasons the company's original cake shop in Hall Gate, Doncaster, could no longer trade profitably and it was decided to dispose of the premises. However, fortunately for us, no acceptable offers were made and as a result the shop was empty for a couple of years. It was then decided that Coopland's should develop the site. An application to the local licensing authority proved successful ... and after ten weeks of major structural work, the old shop was doubled in size and the pub began to take shape ... We wanted the pub to have a Victorian atmosphere and so we went for a very formal design for the interior with, for example, red button-back seating and mahogany panelling.

The Hall Cross is seen here with Coopland's Managing Director David Jenkinson in the line up.

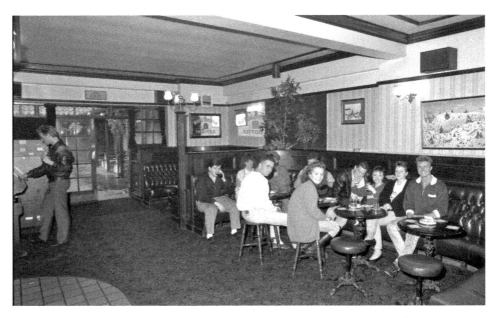

Interior view of the Hall Cross, Hall Gate which was opened on 17 December 1981 (pers. Comm. David Jenkinson, Managing Director of Cooplands) in the company's original cake shop. Renamed Doctor Brown's, May 1997.

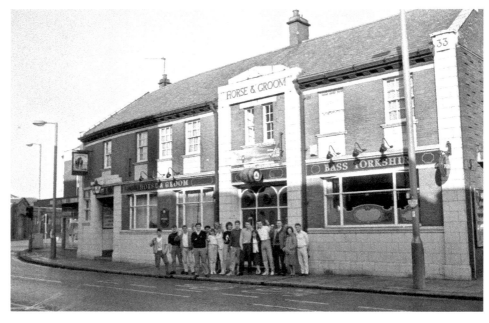

In March 1933 plans by architects Wilburn & Atkinson were passed for brewers, Hewitt Bros Ltd, to rebuild the Horse & Groom in East Laithe Gate which may be traced back to at least 1780 (Hatfield III: 93). The name was changed to O'Neil's in 1996, and back to the Horse & Groom in June 2000.

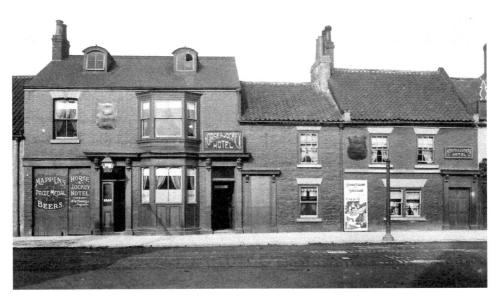

The Horse & Jockey in St Sepulchre Gate was originally titled Horse & Groom (Hatfield III: 81-83). Hatfield (*op. cit.*) also mentions an auction sale of the Horse & Groom, St Sepulchre Gate, 16 April 1791, and that the 'sign changed later by Mr Egley to Horse & Jockey'.

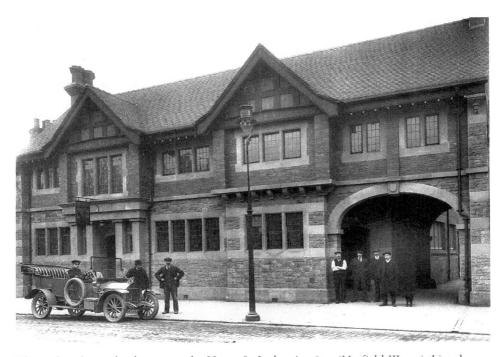

The earliest located reference to the Horse & Jockey is 1815 (Hatfield III: 92). Listed in the past owners are William Walker; Arthur Wright; Thomas Needham, Mappin's Masborough Old Brewery Ltd; William Stones Ltd. Plans were passed during October 1912 for Mappin's to rebuild the premises.

A deed of 25 April 1855 notes the sale of land, later occupied by the Hyde Park Tavern, from William Senior the elder to Mr Robert Taylor. The pub at the corner of Carr House Road/Nelson Street, Hyde Park may be traced to at least 1856 (Hatfield III: 90). A full licence was granted to the premises in 1951 (*Don. Chron.* 8 March 1951).

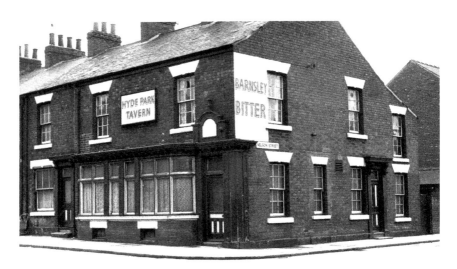

The premises closed 9 February 1971 (deeds held in D.M.B.C. Legal and Admin Directorate). A letter (in the Hyde Park Tavern bundle) dated 26 Jan 1971 states:

> Arrangements have been made for the Hyde Park Tavern to cease trading after licensing hours Tuesday 9th Feb and for the tenant to vacate the premises the following day ... The Corporation effected entry on the property on 12 February 1971. The total compensation was £13,027. 02*d*. The purpose of the acquisition was for 'clearance and development'.

The pub's owners included Robert Taylor; Joseph Senior; Daniel and George May (acquired February 1867); Warwicks & Richardsons Ltd (acquired 1898).

The King's Arms in St Sepulchre Gate extended back to at least 1781 (Hatfield III: 77). Plans were passed in March 1913 for rebuilding the premises for C. A. Ream. This work was needed for the widening of St Sepulchre Gate. In a list of past owners were John Hewitt; Alfred Ream & Son; Bass, Ratcliffe & Gretton Ltd. On 10 December 1959, the *Don. Chron.* announced that the Kings Arms' site had been bought by the shoe firm W. Barratt & Co. Ltd.

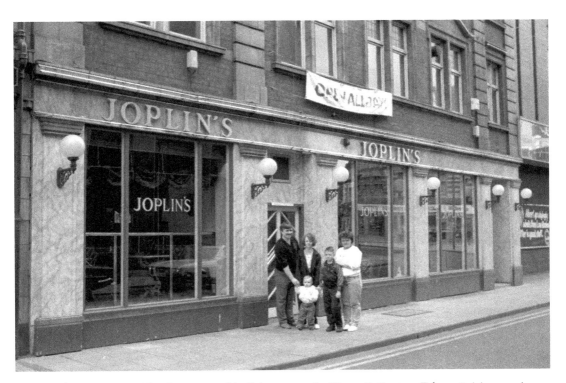

Joplins in West Laithe Gate opened in February 1981 (*Don. E. Post* 24 Feb. 1981) in premises formerly known as the Spread Eagle. The pub was renamed Tut 'N' Shive, 1 April 1992.

A King's Head Inn occupied a site in the Market Place until 1792. The earliest mention to the East Laithe Gate King's Head has been found in the 1793/94 window tax assessment. Plans were passed to rebuild the pub to the designs of Herbert Athron in June 1895. Under the heading 'Replacement for King's Head' the *Don. Gaz.*, 18 Aug. 1965, reported: 'Shops, stores and staffrooms are likely to replace the King's Head Hotel, which is to be demolished as part of the large redevelopment scheme between Hall Gate and East Laithe Gate. Work is underway on a new "split level" public house to replace the King's Head only a short distance to the rear of the present public house.' The licence was transferred (Ordinary Removal) to new premises in the Bradford Row precinct on 10 November 1965 (Licensing Register, Don. Law Courts) and the old premises were demolished. Past owners of the pub included Margaret Walker; Hewitt Bros; Hammond United Breweries Ltd.

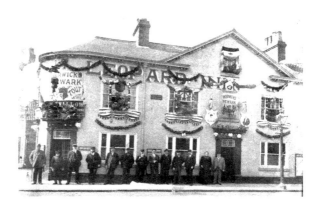

Formerly nicknamed 'the Cat', the Leopard at the West Street/St Sepulchre Gate corner harks back to at least 1821 (Hatfield III: 93). Plans were approved for rebuilding the premises in February 1909, the *Don. Chron.* 5 March 1909 reporting these details from the Adjourned Brewster Sessions:

> Plans for the rebuilding of the Leopard Inn were submitted by G. W. Andrews on behalf of Messrs Warwicks & Richardson. He explained that the work proposed to be done involved the pulling down of several properties, and the setting back of the present building line, in order to make West Street wider at that end. There would be no increased facilities for drinking. – the plans, which were prepared by Mr Beck, were passed.

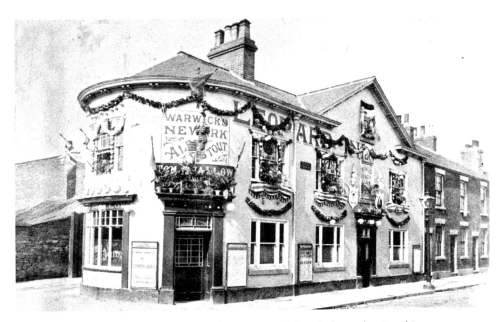

In the *Don. E. Post*, 18 Nov. 1982, Jack Sutton reminisced about the time his grandparents Mr and Mrs Tom Swallow ran the Leopard:

> They opened at 5.30. a.m. – yes a.m. – and ready on the counter in the chill dawn would be a row of coffee and rums costing tuppence each with which Plant workers fortified themselves on their way to start a 6 a.m. shift. The pub then stayed open, selling bitter at tuppence a pint, cigarettes five for an old penny, thick twist a penny, until 11.30 in the evening – an eighteen-hour day ... spirits arrived in bulk – in barrels, like beer – and were decanted by the staff into bottles as required. So great was the alcoholic haze during this operation that the fumes would make people ill.

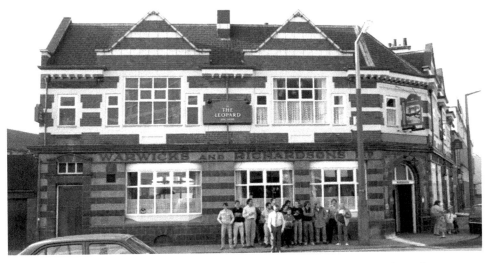

The rebuilt Leopard at the St Sepulchre Gate/West Street corner. Among the pub's past owners were James Milnthorpe; Alfred Eadon & Co. Ltd; Warwicks & Richardsons Ltd.

According to Hatfield III: 87, the Little Red Lion had existed in the Market Place from at least 1783. Interestingly, Hatfield refers to the pub's Market Place location at this period as 'back of shambles'. The pub's title was probably prefixed with 'Little' to avoid confusion with the 'larger' Red Lion, also located in the Market Place.

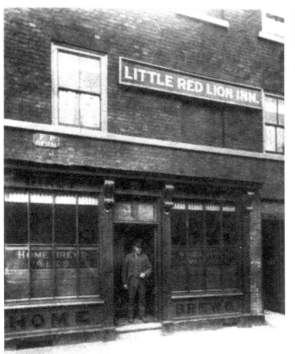
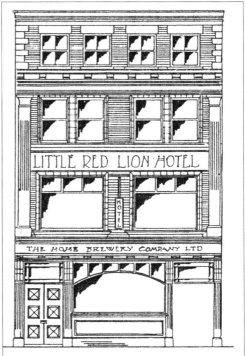

A noted owner and landlord of the Little Red Lion was Stephen Peters. He died on 14 Jan. 1919 and his obituary stated that he was father of the licensing trade in Doncaster. He went into the Little Red Lion in 1868 and had been owner of the property for 50 years. Peters also brewed ale in his own brew house on the premises. The pub was substantially altered to the designs of Wilburn & Atkinson in 1928 remerging with a new name, the Olde Castle. The Little Red Lion's past owners included John Stott; Stephen Peters. The owners, the Home Brewery Company, who were responsible for rebuilding the premises and the name change, may have wanted to acknowledge the existence of an old Roman Fort that was formerly situated nearby. The first 'modernisation' plans, produced by local architects Wilburn & Atkinson, show a three-storey hotel and it is curious to observe that the name Little Red Lion appears on this proposal. But it is tempting to suggest that the brewery considered the 'three-storey' idea too ambitious, as a structure with two storeys was erected instead.

A Lord Nelson Inn, pictured on the extreme left, dating from at least 1811, existed in the Market Place until 1870 (*D.N.L. Gaz.* 5 August 1870) when the site was required for the construction of the Corn Exchange. The last landlord was George Ewing who had purchased, earlier in February 1869, the Old Brewery Tavern beer house at the Cleveland Street/Printing Office Street corner. Consequently, he made an application for the full licence of the doomed Market Place Lord Nelson to be transferred there. It is unclear at this time whether he wanted to transfer the name too. In any event the application for the full licence was refused.

Above right: In an account of the Brewster Sessions, *D.N.L. Gaz.* 2 Sept. 1870, it is mentioned: 'Mrs Frances Ewing then applied in person for a spirit licence for the beer house she then occupied – the Brewery Tavern ... She said she was the widow of George Ewing, who kept the Lord Nelson in the Market Place.' The licensing bench turned her application down just as they had done her husband's a year earlier. However, in the *D.N.L. Gaz.* 23 Sept 1870, appears the first located reference to the site being titled Lord Nelson. Frances seemingly vacated the premises soon after as she is not recorded in the 1871 census. Nevertheless it seems obvious that she was responsible for hoisting the name Lord Nelson in this location and sinking the Old Tavern sign.

Below right: The Lord Nelson was rebuilt in 1934 to facilitate the widening of Cleveland Street. The premises were granted a full licence in 1940 (*Don. Chron.* 11 April 1940). The pub has been renamed the Jockeys.

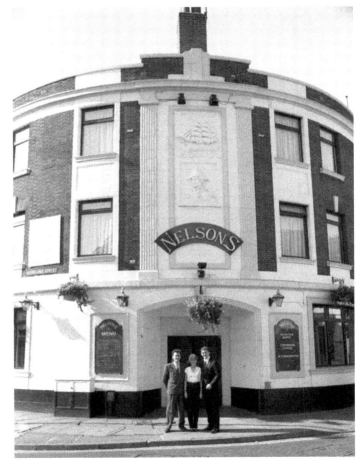

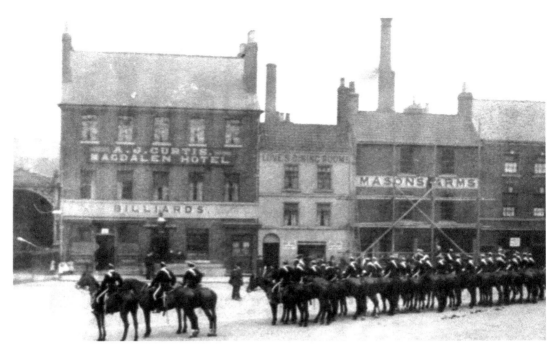

The Magdalen on the south side of the Market Place may be traced to at least 1872 (*D.N.L. Gaz.* 14 June 1872). To be found among the past owners was Samuel Johnson & Sons. It is thought that the inn existed prior to 1854, when the licence lapsed until 1870.

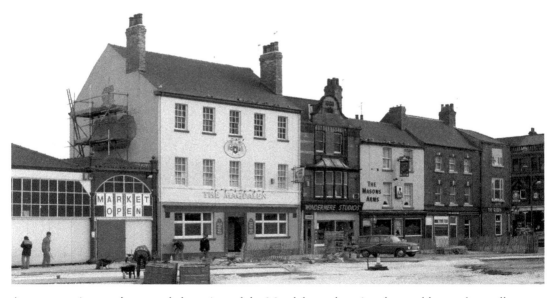

An opportunity to take a good clear view of the Magdalen, otherwise obscured by market stalls, was provided when alterations were taking shape in the area. The name was changed to Bar-NY in August 2004.

The existence of an inn on this site in French Gate can be traced to at least 1421. Before acquiring the name 'Mail Coach' the premises were also known as the 'Hynd', 'Hynd on the Hoop' and 'White Hart'. The *D.N.L. Gaz.*, 3 May 1794, provides us with the earliest reference to Mail Coach by stating: 'Hart & Hind now under title Mail Coach Inn, French Gate.' The premises were demolished *c.* 1908 for the construction of North Bridge. On 9 Oct. 1908, the *Don. Gaz.* records the town clerk's statement to the licensing justices that the Doncaster Corporation would not apply for the renewal of the Mail Coach Inn's licence, an inn which they had recently purchased. In a list of past owners are Broughton Boston; John Elwiss; James Milnthorpe; Hewitt Bross; Alfred Eadon & Co. Ltd; Warwicks & Richardsons Ltd; Doncaster Corporation.

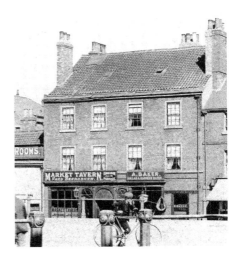

An earlier Market Inn existed on the site of the 'wool market' until 1862. The *D.N.L. Gaz.* of 5 Dec. notes: 'Mr White offered for sale Market Tavern and premises adjoining. The removal of these buildings is rendered necessary for the extension and improvement of the Cattle Market.'

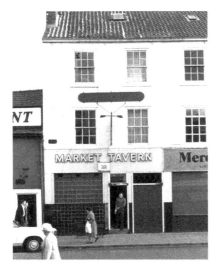

The *Don. E. Post* on 24 November 1978 reported the following under the heading 'Tavern may change into a shop':

John Smith's Brewery have been given permission by Doncaster Council to alter the pub for retail shopping use ... The brewers confirmed that they are "considering the future of the property" ... The wife of the pub manager Keith Brown said that a notice about the planning application had been posted on the door and that was the first she knew of the proposals...

The pub subsequently closed and among the former owners were Whitworth, Son & Nephew, and John Smiths.

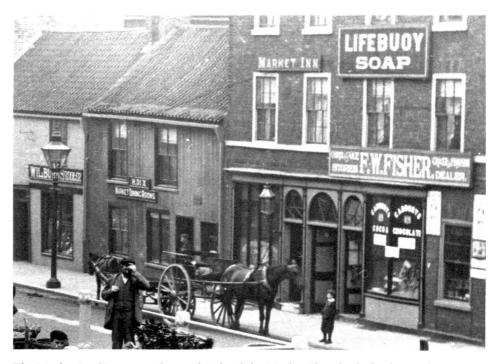

The Market Inn/Tavern on the south side of the Market Place harks back to at least 1870 (*D.N.L. Gaz.* 5 August 1870). Plans were passed in November 1911 authorising Whitworth, Son & Nephew to alter the premises.

This St Sepulchre Gate pub was formerly titled Hammer & Anvil, Hatfield: III: 86 stating: '... name changed from Hammer & Anvil to Marquis of Granby on 23 Sept 1814'. Consequently the first located reference to Marquis of Granby is 1814 (Hatfield III: 86). The *D.N.L. Gaz.* 27 April 1849 advertises the Inn for sale and details its layout:

> ... on the Ground Floor – Dining Room, Parlour, House Bar, and excellent Brew house, and containing on the First Floor Six good Bed-Rooms, and Four on the Second Floor with ample cellarage under the Premises. Together with a very spacious Inclosed Yard and Stabling for 44 horses, with Hay and Corn Chambers over the same, Pigsties and other Conveniences.

The *D.N.L. Gaz.*, 13 May 1853, notes: 'Sale Marquis Granby St Sepulchre Gate, recently rebuilt.' The licence was withdrawn in 1856 (Hatfield III: 86).

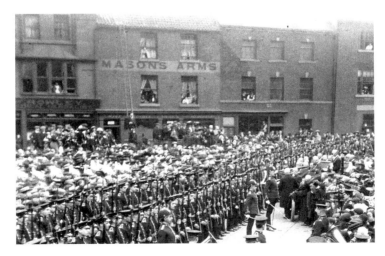

The Mason's Arms was built in the Market Place in 1701 (Scargill & Scargill, 1989). The premises were rebuilt 1788/89, and formerly titled the Bell, the Sun, and the Skinner's Arms (ref. as above). Alterations were approved in April 1893 for Mr Vaux. Former owners were Thomas England; William Kitching; William Waller; John Parkinson; William Brabiner; Thomas Vaux.

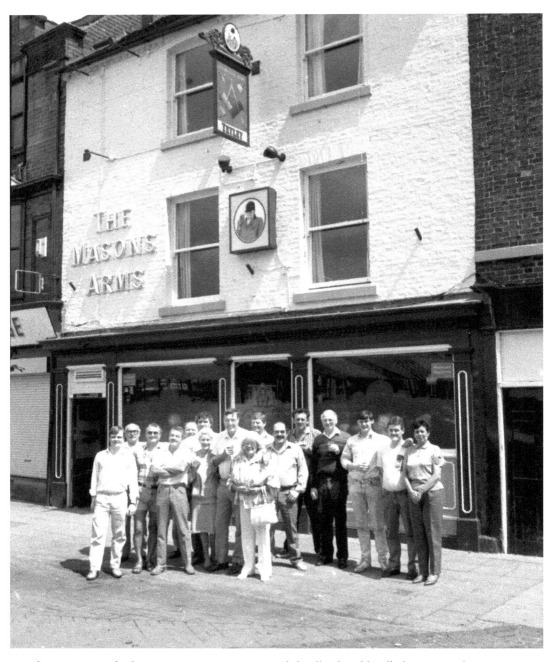

Regulars pose outside the Mason's Arms in 1988 with landlord and landlady Terry and Denise Hull. The pub won a heritage award in 1989.

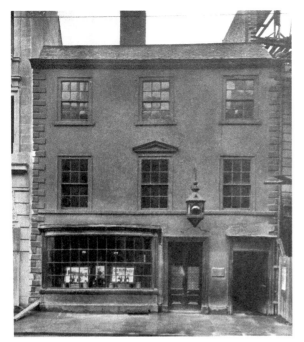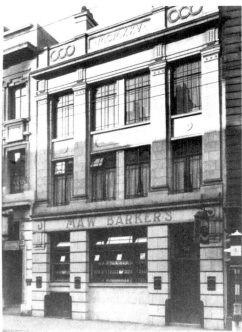

Above left: The Maw, Smith and Barker families intertwined in business as mercers, linen and woollen drapers as well as and wine and spirits merchants for much of the first half on the nineteenth century. The first located reference to a wines and spirits connection is in the *D.N.L. Gaz.*, 23 Sept. 1814: 'Richard Maw has commenced [a] wine and spirits business.' The *D.N.L. Gaz.*, 21 July 1854 states: 'High Street Wine Vaults. John Maw, in business 20 years, has taken into partnership his nephew John Maw Barker. Firm now Maw Barker.' The first located mention to Maw Barker at the 56 High Street location is in the *D.N.L. Gaz.* 7 Jan. 1862: 'John Maw Barker, wine and spirit merchant has moved to 56 High Street.' Besides the Maw Barker name the premises at some point appear to have also adopted that of Princess Victoria Vaults. It was also noted as the Vine (*D.N.L. Gaz.* 28 Aug. 1863).

Above right: The premises held a six-day licence (closed on Sundays). Plans were passed to rebuild Maw Barkers to the designs of T. H. Johnson for Samuel Allsopp & Sons Ltd in February 1923. The *Don. Chron.* 6 October 1955 under the heading Doncaster Public House (Opened 1792) to be sold reported:

> Maw Barkers, High Street ... is to be sold by auction for the owners, Ind Coope and Allsopp Ltd because it is considered by the brewers more profitable to sell than to run for normal profit. The inflated price of property in Doncaster's high Street, they say, is the reason for this decision. The premises will be sold on October 26 by a London firm of auctioneers, without the benefit of the licence, which will act as a restrictive clause preventing its further use as a hotel.

Taking into account the references already provided, the mention of the premises opening in 1792 can only be regarded as incorrect. The last licensee was Cliff Morley.

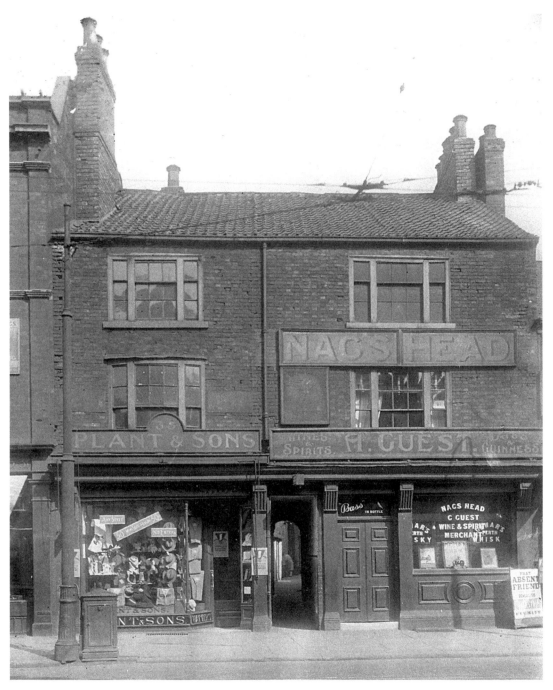

Plans were passed to rebuild the premises to the designs of T. H. Johnson for Warwicks & Richardsons Ltd in April 1930. This was for the St Sepulchre Gate widening scheme. The premises were modernised in 1969 (*Don. E. Post* 19 Dec. 1969). Among the past owners were Frederick Turner; Richard Henry Hodgson; Warwicks & Richardsons Ltd. The Nag's Head in St Sepulchre Gate may be traced to at least 1812 (*D.N.L. Gaz.* 7 July 1812).

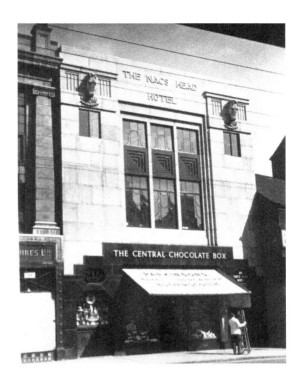

The rebuilt Nag's Head in St Sepulchre Gate. The premises closed in Feb. 2006.

The New River Tavern/Inn is traceable to at least 1843 (*D.N.L. Gaz.* 30 Sept 1843). The licence lapsed, 8 Jan. 1937 (*Don. Gaz.* 11 Feb. 1937). Listed among the owners are the River Dun Co. Ltd; John Elwiss; William Ward; Nicholson Bros; Whitworth, Son & Nephew Ltd. The premises were converted to a cafe in 1939.

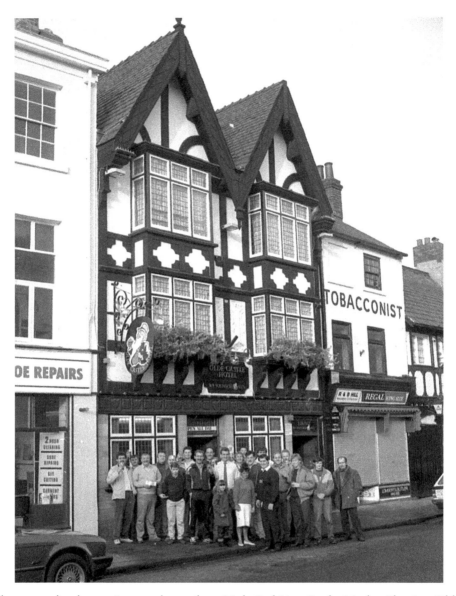

The reason for the 1928 name change from Little Red Lion (in the Market Place) to Olde Castle has not been discovered. And it is interesting to see that the finished frontage is considerably different from the one originally proposed; it is in the style of architecture derogatorily referred to as the 'Brewers' Tudor', has two gables and carries the Olde Castle name.

Whatever transformation the premises have undergone, or the various names they trade under, does not seem to have affected the longevity of tenants. Robert Smith held the tenancy between *c.* 1945 and 1960, and Harry Stocks 1960 to 1984. Terry Oates was there from 1984 to 1996 and a stalwart of the Licensed Victuallers Association as were his predecessors, Harry Stocks and Stephen Peters. Further, Terry was the Association's President and Chairman of Doncaster Pub Watch which was formed with the cooperation of the South Yorkshire Police and the Brewer's Association in an effort to combat pub violence.

The earliest located reference to the Old Exchange Brewery & Tavern in Cleveland Street is 1867 (White, *E. Riding Dir.*). Plans were passed for rebuilding the brewery for Whitworth, Son & Nephew in 1897, and for a new frontage for the tavern for the same owners in October 1909. The premises were converted for office accommodation in the 1940s and were later demolished.

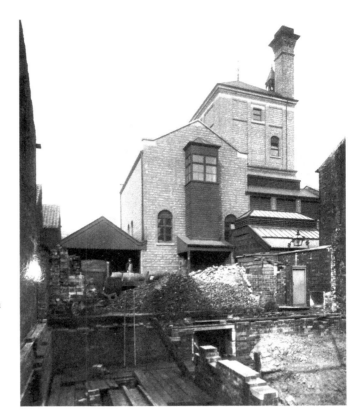

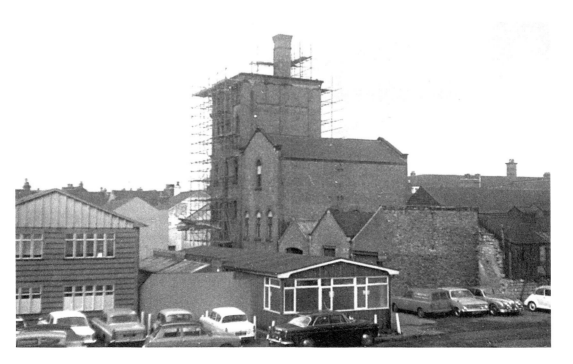

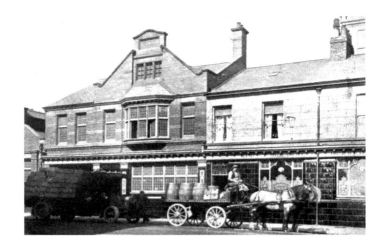

The Old Exchange Brewery and Tavern complex was converted to temporary office accommodation during 1946 by Doncaster Corporation. The licence was refused *c.* 1939. The final demolition was in 1982 (Colonnades development). The owners included W. Cooke; Joseph Erskine Bainbridge; Thomas Windle; Whitworth, Son & Nephew; Doncaster Corporation.

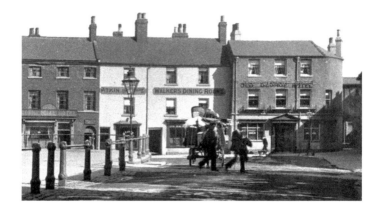

An earlier inn of this name existed on the site of the Corn Exchange until the beginning of the nineteenth century. The Old George on the south side of the Market Place extends back to at least 1800. A sale notice in the *D.N.L. Gaz.,* 15 Sept. 1826, includes the following about the premises:

> Stables for upwards of forty horses, extensive chambers and granaries, brew house, barrack rooms ... a detached yard, containing upwards of eight hundred square yard of ground ... The Old George Inn occupies forty-nine feet in front of Magdalens and Market; the outbuildings attached to it alone command a valuable frontage of 128 feet in Bowers Fold, and 78 feet in Silver Street and a considerable portion of them, at trifling expense might be converted into tenements, without encroachment on the principal conveniences of the property.

Among the past owners were Anne Hall; James Battison; William Mapplebeck; Whitworth, Son & Nephew Ltd. The premises was renamed Courtyard in 2004.

CHAPTER 4

PALACE BUFFET – ROYAL LANCER

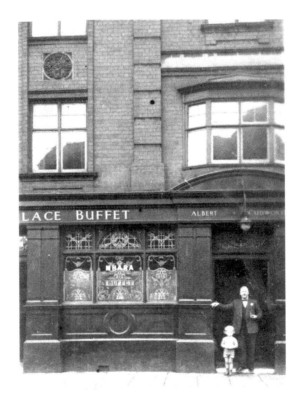

The Palace Buffet in Silver Street, replacing the Young Union which closed *c.* 1910, adjoined the Palace Theatre (later Essoldo cinema), dating from 1911 (*Don. Chron.* 3 Jan 1963). The Palace Buffet was once the favourite haunt of many music hall stars, including Florrie Forde, G. H. Elliott, Charlie Chaplin, Gertie Gitana, and Frank Randle. It closed in 1963 and the *Don. Chron.* 3 Jan 1963 under the heading 'The Palace Buffet fades away' reported:

> The decay of the music hall has a close connection with the death of the Palace Buffet. The Palace Theatre (known more recently as the Essoldo Cinema) stands next door to the Buffet in Silver Street. They were built together in 1911 by five local businessmen who called themselves the Palace Theatre Company.

The *Don. Chron.* 3 Jan 1963 also stated:

Soon both [the Palace Theatre and Buffett] will be demolished and eventually in their place will rise shops and offices and a bowling alley ... Even when the theatre became a cinema, and the Grand Theatre on the far side of town Doncaster's only place for live entertainment the Buffett attracted artists, for it was the local headquarters of the Music Hall Artists' Railway Association. This splendidly named body furnished artists with vouchers enabling them to travel half price on the railways. On a Monday morning the scene at the Buffet was like a curtain call ... Something of a scandal was caused in August, 1911, when the theatre and the Buffet met the gaze of Doncastrians for the first time. Critics spoke of 'the florid glories' of this 'Oriental-looking building.' But it was granted in some circles that it had a 'general air of solidity and magnificence'.

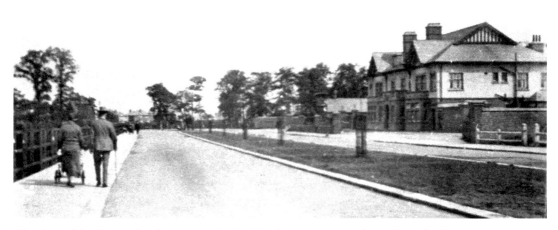

Mention of the licence for the new Park Hotel in Carr House Road (on the right) being transferred from the Wood Street Hotel in Wood Street was made in the *Don. Gaz.* 10 Feb 1922. The *Don. Gaz.*, 20 July 1923, records a new hotel for Carr House Road and the *Don. Chron.*, 6 June 1924, carried an article lamenting the passing of the Wood Street Hotel.

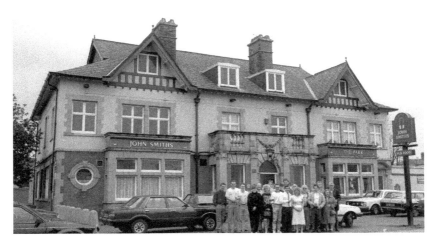

Regulars of the Park Hotel pose with popular landlord Pete Dodd in 1989.
Pete's dad Ronnie Dodd was a former Doncaster Rovers player. The premises
were refurbished in 2001.

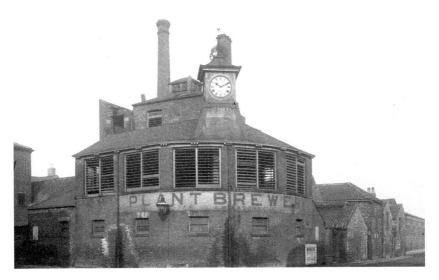

The Plant Brewery, Sunny Bar, was built in 1852 (*D.N.L. Gaz.* 1 Oct. 1852)
for Arthur Joseph Smith behind premises (for some time known as the
Queen) which he occupied as a wine and spirits merchant. The builder of the
brewery was Henry Worth of Sheffield; and G. Wilson was the architect. The
D.N.L. Gaz. (*op.cit.*) contains an account of the roof-rearing supper given to
the workmen by A. J. Smith on 24 Sept. 1852 with about fifty people being
present. Mention was made of the chimney which stood 75 feet high and
on a 6-foot stone base. The supper was provided by Mr and Mrs Smith of
the Wellington Hotel. The founder of the feast (A. J. Smith) was not present,
the chair being taken by W. M. Phillips. The premises were demolished in
1902 in the Corporation's Sunny Bar/Market Road improvement schemes.
Listed among the owners were Arthur Joseph Smith; Daniel and George May;
Thomas Blackburn; James Milnthorpe; Alfred Eadon & Co. Ltd.

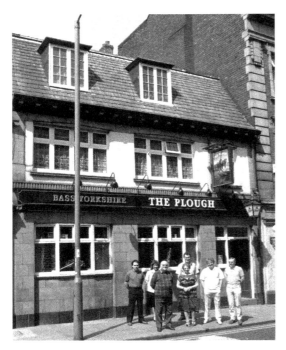

Located references between 1854 and 1870 reveal that this pub in West Laithe Gate was formerly titled the Sheffield House. The first mention of the name Plough in West Laith Gate was found in 1880 (*D.N.L. Gaz.* 16 Jan. 1880). The premises were altered in 1934 and the past owners included William Henry Palmer, and Hewitt Bros.

The Plough may be traced to at least 1774 (Anelay's account book) and occupied a site east of the theatre which stood in New Street, opposite the entry of Scot Lane into the Market Place. The premises were demolished *c.* 1848 and the licence and name transferred to premises in the Corn Market situated in a line of buildings nearly opposite to Sunny Bar. The 'new' premises were demolished *c.* 1868 for the construction of the south wing of the Market Hall (Corn Exchange).

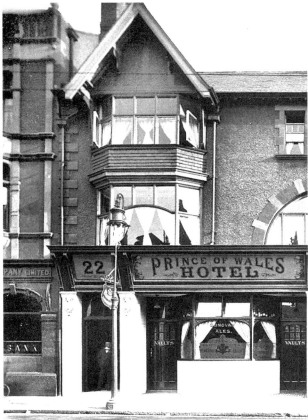

Above left: In the late eighteenth century these premises existed as the private house of Edmund Cartwright, inventor of the power loom (Hatfield: I: 331). In later years they were owned successively by Richard Robson & Co. (1822: Baines, *W. Riding Dir.*) and Richard Robson & Co. (*D.N.L. Gaz.* 27 Nov. 1840) and Joseph Fritchley & Co., who were wine and spirits merchants. The earliest located reference to the Prince of Wales name on this site is 1885 (*D.N.L. Gaz.* 12 Jan. 1885).

Above right: Plans were passed during January 1908 for the Worksop & Retford Brewery Co. to alter the Prince of Wales. A Doncaster Corporation minute of 22 June 1909 gave permission for contractors to erect temporary hoardings during alterations in front of the Prince of Wales. On 2 July 1957 the corporation gave permission to Wade Furniture Stores Ltd to change licensed premises (Prince of Wales) to a furniture store. The *Don. Chron.*, 2 Jan. 1958, reported: 'Prince of Wales, Baxter Gate closed its doors at the end of [last] year.'

The Prince of Wales at the Carr House Road/Nelson Street corner may be traced to at least 1863, the *D.N.L. Gaz,*. 26 Aug. 1864, stating: 'Spirit licence refused for Prince of Wales, George Haughton had kept it one year.' It was rebuilt in 1898, to the designs of Athron & Beck, the *Don. Gaz.* Friday 14 Oct. 1898 recording: 'A dinner in commemoration of the opening of the new Prince of Wales was given last Monday.' A full licence was granted in 1897 (*Don. Chron.* 27 August 1897).

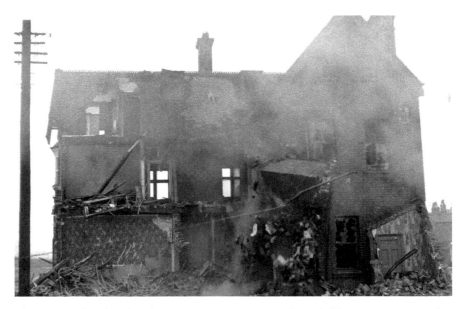

The Prince of Wales closed 18 Oct. 1973 (correspondence held in D.M.B.C. Legal and Admin. Directorate) and was demolished. Among the owners were George Haughton; Francis Ogley; James Milnthorpe; Alfred Eadon & Co. Ltd; Warwicks & Richardsons; John Smith's Brewery.

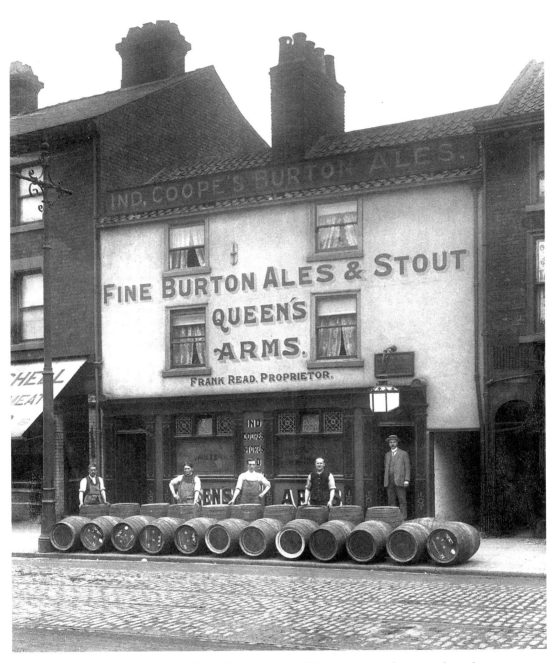

The Queen's Arms in St Sepulchre Gate was probably in existence for a number of years as a shop and beer house before a reference to the name was located in 1881 (Jackson: *Doncaster Charities: 77*). However there is a reference of 1856 (*D.N.L. Gaz.* 16 May 1856) that relates to the pub being titled Queen's Head. The premises existed as a beer house until 1949 (*Don. Chron.* 14 April 1949).

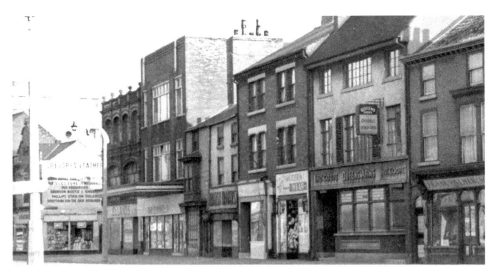

When owners Ind Coope & Allsopp submitted rebuilding plans in 1938, they were passed. At this time the brewery must have thought it was above all the adjournments and delays experienced by other brewers. How wrong they were and what a cruel blow fate was about to deliver them, because nothing, it would appear, was mentioned about the proposed construction of an Inner Relief road to link up with the East By-Pass. The Queen's Arms was directly on the route and closed on Saturday 29 February 1964 (*Don. Gaz.* 5 March 1964). It was demolished in August 1964 (*Yorks E. Post* 27 Aug. 1964) after only twenty years of existence, holding the record for being Doncaster's shortest-lived rebuilt pub.

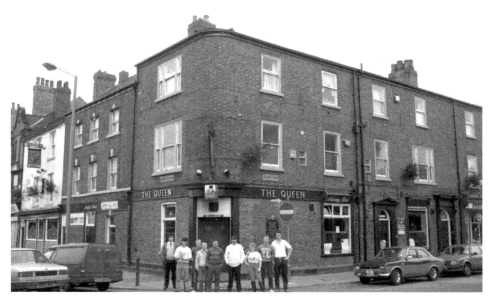

The premises housing the Queen at the Sunny Bar/Market Place corner had been occupied by Joseph Smith, a wine and spirits merchant, from at least 1824. The first located reference to the Queen is 1891 (*Don. Gaz. Dir.*). The premises were altered in 1904 and 1984 (*Don. Free Press* 13 Dec. 1984). Former owners include Arthur Joseph Smith, and Duncan Gilmour & Co. Ltd.

The Railway Hotel at the West Street/West Laithe Gate corner may be traced to at least 1853 (*D.N.L. Gaz.* 21 Oct. 1853). The premises were altered in 1931 and among the owners were William Mapplebeck; Joseph Turner; Whitworth Son & Nephew Ltd.

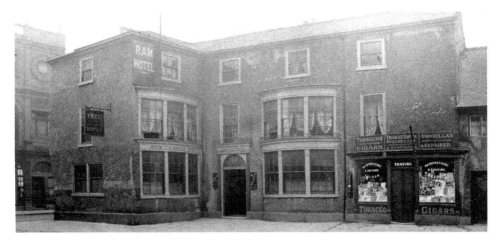

By the beginning of the twentieth century, Doncaster Corporation had embarked on its street-widening schemes and in 1906 it was looking to widen the Cleveland Street/High Street junction, and the Ram was standing in the way. The corporation purchased the pub from Fisher & Co. for £5,500. As the corporation only required a portion of the site for street improvements, the remainder was to be sold. In November 1907 the corporation agreed to a purchase price of £4,500 offered by A. Greensmith on behalf of the Planet Trading Co. Ltd. References to the Ram stretch to at least 1793. And the Ram itself was built on the site of another inn, the Bay Horse. The Ram was demolished during 1909 (*Don. Chron.* 22 Jan. 1909).

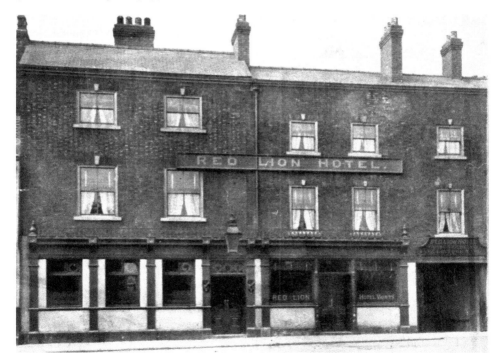

The Red Lion on the west side of the Market Place may be traced to 1742 (Hatfield III: 90). The reference relates to John Jaques, who was later noted as a tenant of the inn.

The Red Lion was altered in 1911 and 1925 and the ownership changes have involved Joseph Hawksworth; George Haggart; George Robinson; New Trent Brewery Co. Ltd; Barnsley Brewery Co. Ltd.

The Regent Hotel, 1935.

The Regent Hotel has become a well-known and much revered institution under the Longworth family, now spanning four generations. 2010 will be the hotel's seventy-fifth birthday and many celebrations and promotions are planned. It was established by Nellie Longworth in 1935 and has subsequently been run by her son Colin and his wife Peggy and is presently managed by her grandson Mike Longworth and his son Simon. In 1976 the Parade Bar was opened followed by the Archives Bar in 1980. During the late 1990s it became a functions venue, obtaining a Civil Wedding Licence in 2000. Numerous well-known personalities and pop bands have stayed at the hotel including Oliver Reed, the Beatles, Sandie Shaw, Lonnie Donegan, the Kaiser Chiefs, and Showaddywaddy.

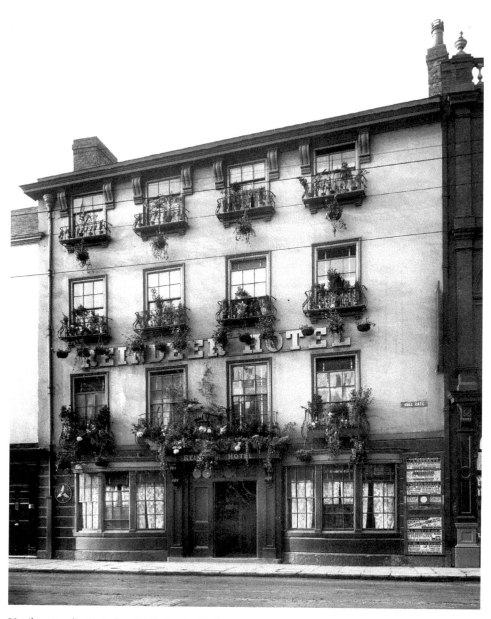

Until 1781 the Reindeer building in Hall Gate was a private dwelling, dating from around 1735. At this time, there was a pinfold adjoining the western side, with rich meadows and green pastures to the rear. According to C. W. Hatfield: 'The building's admirable situation and access to the main roads suggested to the tenant William Carnelly its adaption to an inn.' The Carnellys were noted innkeepers at Rotherham and Sheffield and were proud of their name. At one time during William's tenure, the property was known as Carnelly's Hotel. As patronage increased, the Reindeer soon became a venue for all kinds of events. In 1787 a Mr Banks gave a course of readings on the principles of mechanics, pneumatics, hydrostatics, optics, electricity and astronomy. When James Judd took over in 1812, he used one of the rooms for promoting fine arts, music and culture.

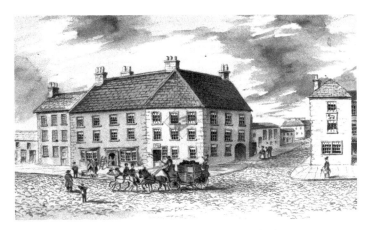

Although many wholesome activities took place at the hotel, there was an unsavoury side to its character. For many years the stable yard at the rear provided the principal venue for what became regarded as an extremely distasteful sport – cockfighting. Cockfights or 'mains' as they were so called, attracted high prize money, as illustrated here in a notice dated 4 March 1808, and were frequented by county and titled persons such as Harry F. Mellish of Blyth Hall. However, it will be as an important posting and coaching house, conveniently situated on the Great North Road, that the Reindeer will always be remembered. Coaches to many parts of the country departed from the Reindeer and Richard Wood, Doncaster's principal coach proprietor, had offices there. The drawing showing a coach outside the hotel evokes the atmosphere of the time.

DONCASTER COCKING.

THE Gentlemen's Subscription Main of Five Guineas each Battle, will commence fighting at Mr. T. Foster's Pit, the Rein Deer Inn, Doncaster, on Monday the 21st of March instant, and three following Days. There will be a Welch Main of sixteen Cocks on one of the above Days for One Hundred Guineas; the Weights from 4lb. 4oz. to 4lb. 8oz.

Feeders, { THOMPSON. BROOKES.

It was probably due to the revenue earned from coaching traffic and its patrons that the Reindeer was extensively altered around 1837. A notice in the *Doncaster Gazette* for that year announced: 'The Reindeer Inn and posting house has been enlarged and improved. The great public dining room has been extended and decorated by a London artist and many additional bedrooms added.' The renovation work included giving the building an extremely pleasant Georgian facade, which it retained for nearly 130 years. For a time in 1851 the Reindeer closed because with the coming of the railways, coaching traffic disappeared virtually overnight. However the closure was short-lived and the premises reopened later in the same year.

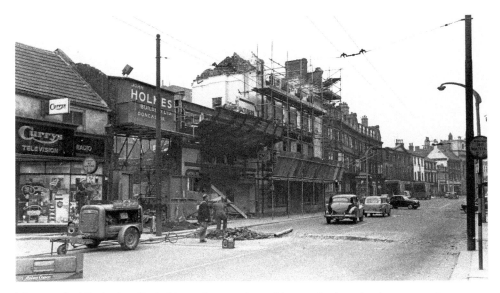

The so-called 'Swinging Sixties' brought an upheaval in standards and values to nearly every aspect of daily life. Consequently, this put numerous old buildings like the Reindeer under threat. Also, new roads, housing estates, public buildings and shopping centres were appearing all round Doncaster. Further, the town centre was designated a commercial area, so this put a high premium on central sites. The Reindeer closed in 1959 (*Don. Gaz.* 26 Nov. 1959) and was demolished in 1962 (*Don. Chron.* 18 Jan. 1962). The past owners were William Carnelly; Frederick William Fisher; Frederick William Masters; Planet Trading Co. Ltd.

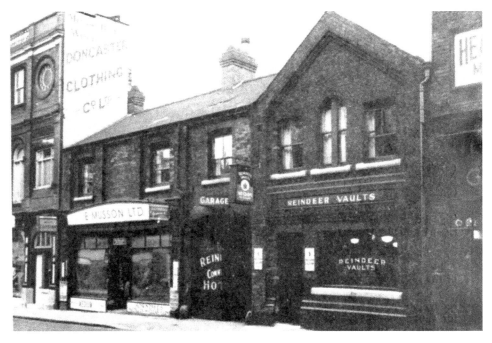

The Reindeer Vaults were situated in Cleveland Street.

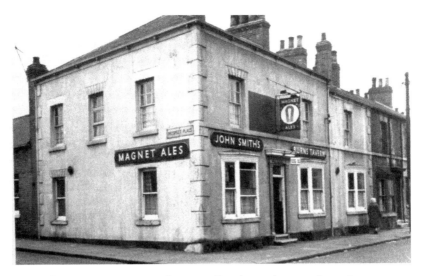

The Robert Burns Tavern in Cemetery Road may be traced to 1855
(*D.N.L. Gaz.* 31 Aug. 1855). It was closed on 10 Oct. 1971
(Correspondence held in D.M.B.C. Legal and Admin. Directorate). A
replacement site was offered within the Stirling Street/Exchange Street
Environmental Improvement Area to the pub's last owners, but this was not
taken. The previous owners were Charles Verity; E. Cooke; Whitworth, Son
& Nephew; John Smith's Brewery.

The original Rockingham in Bennetthorpe was erected in 1778 and,
according to the *Don. Chron.*, 17 March 1922: 'Doubtless took its name
from the Marquis of Rockingham who, on the occasion of a dinner at
the Red Lion Inn at which Colonel St Leger was present, was one of the
founders of the famous St Leger Stakes'. The first host of the Rockingham
was William Bennett, from whose family the name of Bennetthorpe was
derived. Behind the old inn and the adjoining cottage property were a
number of boxes that had sheltered many famous racehorses.

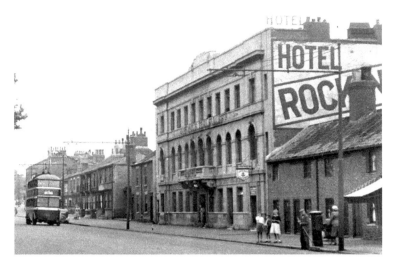

Plans were passed to rebuild the Rockingham in 1922, and the new structure, in the English Renaissance style, was designed by architects, Allen & Hickson. It was completed in 1926 (*Don. Gaz.* 12 Feb. 1926). Just as the old building was erected to cater for the requirements of the Great North Road traveller of the coaching days, the new building was to meet the requirements of the modern road traveller.

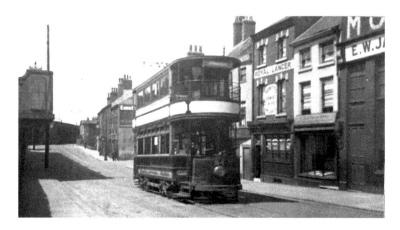

When licensee Richard Oldfield left the Royal Lancer in French Gate after forty-three years in February 1932, he reminisced:

> I had to be up for the greater part of the night during Race Week with traffic passing all through the night and visitors calling. I have had 20 lodgers sleeping on the seats in the smoke room for a shilling each because they could not get anywhere else. The Royal Lancer was a busy inn before the building of the North Bridge placed it in a backwater. At one time there was stabling for six horses, but not many were stabled there as there was no back entrance and only a narrow passage leading to the stables from the front.

The Royal Lancer harks back to at least 1831 (*D.N.L. Gaz.* 16 Sept. 1831). The licence lapsed 8 Jan. 1937 (*Don. Gaz.* 11 Feb. 1937) and listed among the owners were Frederick William Fisher; John Elwiss; Hewitt Bros Ltd.

CHAPTER 5

ST LEGER TAVERN –
TURF HOTEL

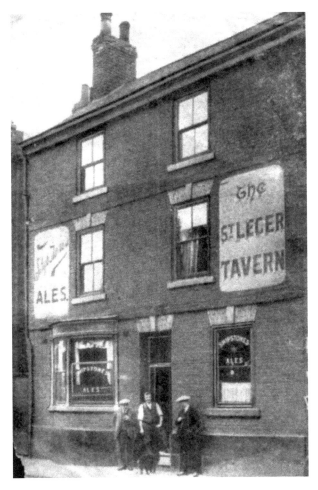

The pub was formerly titled the Three Jolly Blacksmiths and had existed from at least 1813 (*D.N.L. Gaz.* 12 March 1813). The first located reference to St Leger Tavern is 1838, the *D.N.L. Gaz.* 7 Sept. 1838 mentioning: 'St Leger Tavern, late Three Jolly blacksmiths'.

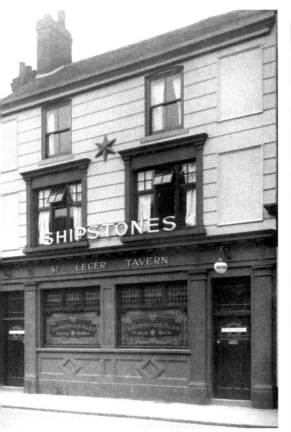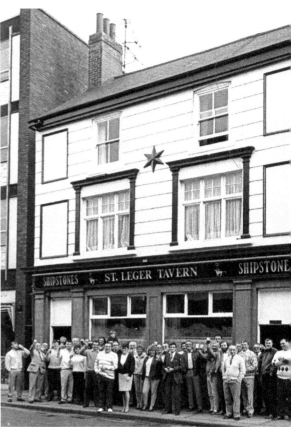

Plans were passed to alter the St Leger to the designs of Wilburn & Atkinson for owners Jas Shipstone & Sons in February 1924. Former owners were Robert Taylor, and Warwicks & Richardsons Ltd.

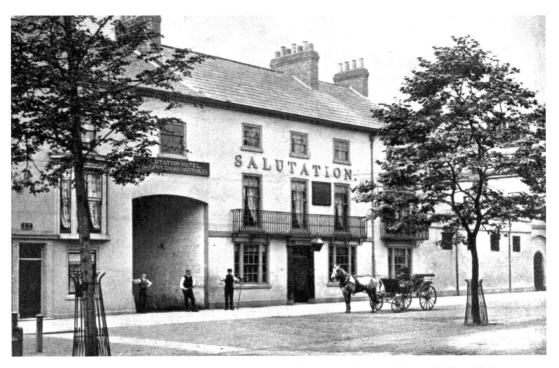

From at least 1744 the Salutation was situated adjacent to the South Parade/Waterdale junction, moving to its present position around 1778. The new pub was designed in a Georgian style. Bethune Green, a local chandler was responsible for the construction from bricks which have since been rendered.

In a sale notice of 1789, the inn was described as 'one of the best accustomed on the Great North Road being used by gentlemen of the turf, most of the principal London dealers and much resorted to during the races and fairs'. Around 1784, with the appontment as landlord of William Hurst, a former stud-groom to Colonel St Leger, of Park Hill, near Firbeck. A stud was established at the Salutation. Many St Leger winners were stabled there, including the Colonel, Touchstone, and the Baron.

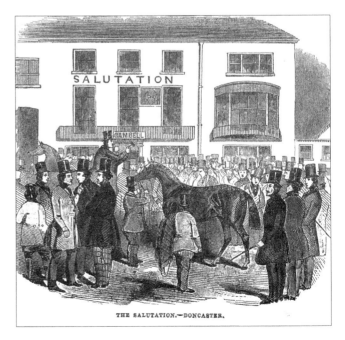

THE SALUTATION.—DONCASTER.

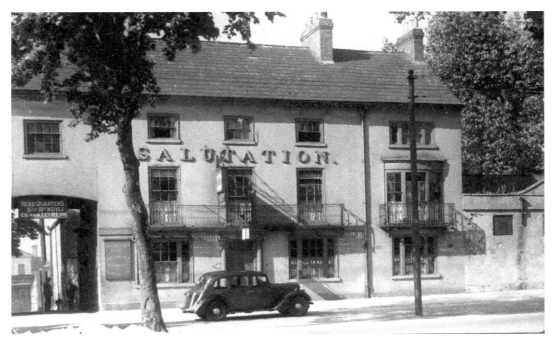

The building was extended in 1831, the brickwork rendered and ornamental balconies added to the first-floor windows. In 1851 the stabling and accommodation for horses was considerably enlarged. On 29 June 1882 there was a murder at the pub and in 1910 a suicide.

In 1937 owners Ind Coope & Allsopp planned to create a new hotel but were frustrated by Doncaster Corporation's plans to extend its proposed inner relief road from South Parade to Chequer Road, thus obliterating the pub's site. Several more plans for a new hotel on an adjacent site were also abandoned for various reasons after the war. Among the past owners were Samuel Johnson & Sons; James Milnthorpe; Ind Coope & Allsopp Ltd.

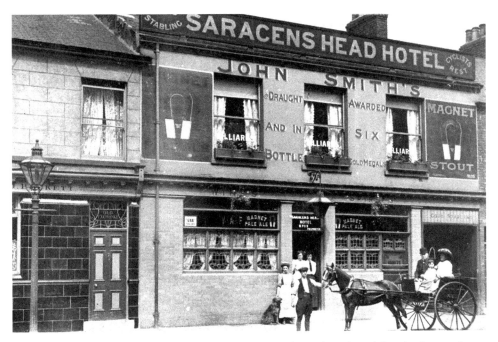

A reference of 1824 (*D.N.L. Gaz.* 17 Sept. 1824) is the earliest found for the Saracen's Head in Cleveland Street. Plans were approved for alterations and stables in 1902.

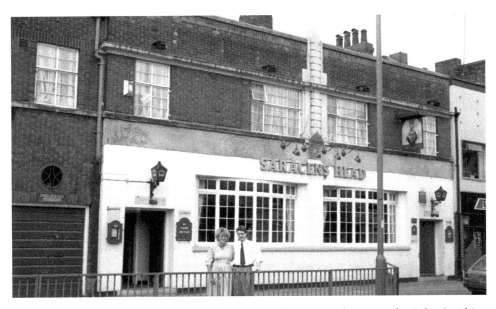

Rebuilding plans for the Saracen's Head were passed in September 1936 for John Smith's Tadcaster Brewery Co. Ltd. Among the previous owners were Samuel Johnson & Sons. The premises have subsequently been renamed Blue Lion & Pineapple (1998), and Great Northern (1999).

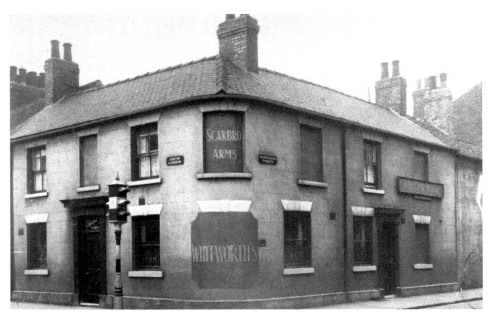

The premises had traded at the corner of Cleveland Street/Spring Gardens as an untitled beerhouse from at least 1862. Scarboro Arms is first located in 1868 (Hatfield: III: 90). The pub was acquired in the Central Area 4 Compulsory Purchase Order, 1959 and conveyed from Whitworth, Son & Nephew Ltd to Doncaster Corporation 6 June 1962 (Correspondence held in D.M.B.C. Legal and Admin Directorate). The licence was transferred to the 'Paddock', Cantley (*Yorks. E. Post* 29 July 1964). Among the past owners were Thomas Martin; Thomas Windle; Whitworth, Son & Nephew Ltd.

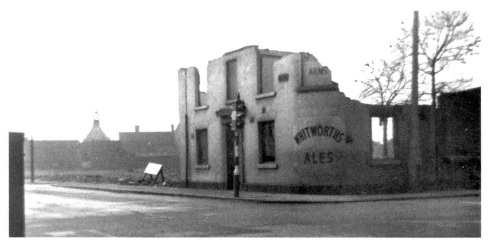

Proposals were submitted in the late 1930s for rebuilding the Scarboro Arms but the scheme never materialised because the site was required for the Golden Acres development. A former licensee of the Scarboro Arms was Albert 'Tabs' Tabor, a past president of the Doncaster and District Licensed Victuallers' Association. The premises obtained a full licence in 1949 (*Don. Chron.* 14 April 1949).

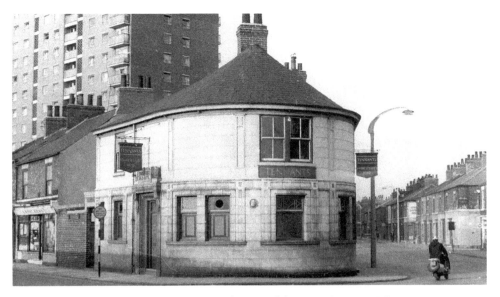

The Shakespeare's Head at the junction of St Sepulchre Gate/St James' Street was probably built by former owner Charles Siddall and dates from at least 1833 (*D.N.L. Gaz.* 6 Dec. 1833). The premises were granted a full licence in 1844 (*D.N.L. Gaz.* 6 Sept. 1844). Plans for alterations and additions, to the designs of Holmes & Son, were passed for Tennant Bros Ltd in July 1930.

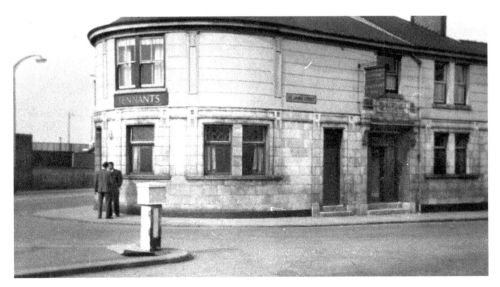

The *Don. Gaz.*, 19 Aug. 1965, carries a picture of the Shakespeare's Head on the last day of its existence; a caption beneath it reading: 'Mr and Mrs G. A. Wombwell and daughter Joyce pull the last pint at Doncaaster's Shakespeare's Head Hotel which closed at the weekend to make way for road improvements. Mr Wombwell was the licensee.' In the list of past owners were Charles Siddall; Thomas Charles Crowcroft; Frederick William Fisher; Tennant Bros.

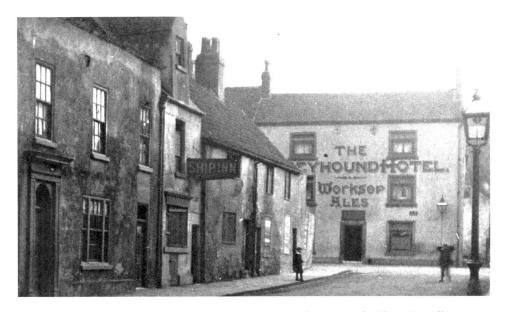

Hatfield III: 52 provides 1782 as the earliest located reference to the Ship, Friendly Street. The licence was opposed at the Borough Licensing Sessions in February 1907; the *Don. Gaz.,* 15 Feb. 1907, reporting:

> Chief Constable Lister stated that he opposed the renewal of the licence on the grounds that it was not necessary ... The locality was well supplied within or very few yards of the house in question ... The Ship was the property of Doncaster Corporation. It was a small house. There [were] no aspersions whatever against the tenant, for it had been kept very clean. After further discussions the Chairman said: 'The renewal of the licence was declined, but the house would be referred for compensation.'

Among the previous owners were George Senior; Elizabeth Dale; Thomas Windle.

The Sidings was opened on 13 Feb 1981, and renamed White Rose in 2002.

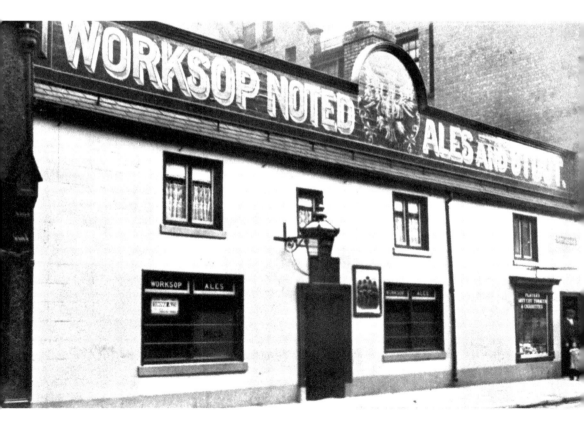

The Spread Eagle in West Laithe Gate may be traced to at least 1831 (Hatfield III: 61). Plans for rebuilding the premises to the designs of Wilburn & Atkinson were passed for the Worksop & Retford Brewery Co. Ltd in February 1923. The pub's name was changed to Joplins when the latter opened in February 1981 (*Don. E. Post* 24 Feb. 1981). Previous owners included the Worksop & Retford Brewery Co. Ltd.

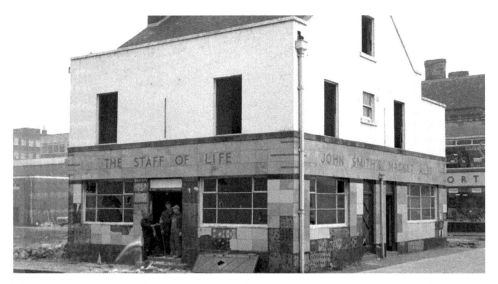

The inn had existed as a beerhouse at the Whitaker Street/ Young Street corner from at least 1855. The title Staff of Life is first located in 1862 (White: *W. Riding Dir.*). Interestingly the *D.N.L. Gaz.*, 22 June 1850, notes that 'two houses were being built by J. Earnshaw in Young Street at the corner of Whitaker Street'.

The Staff of Life existed as a beer house until 1948 (*Don. Chron.* 5 Feb 1948). The premises were altered in 1914, 1936 and rebuilt *c.* 1966 almost on the original site, the *Don. Gaz.* 12 May 1966 offering the following information:

> Work should start within the next few weeks on the new Staff of Life public house in Doncaster's central shopping precinct. This means that the building will be well on the way to completion by the end of the year. The new Staff of Life is to be just across the road from the present building in Princegate which is coming down ... the contract for the new public house, which will cost in the region of £30,000 is expected to be awarded to Walter Firth Limited ... John Smith's say that the new 'pub' exterior of which must blend with the rest of the new development, will be a normal town house with two rooms, and a shop for off-sales.

Previous owners were Sarah Shaw and Ind Coope & Allsopp Ltd.

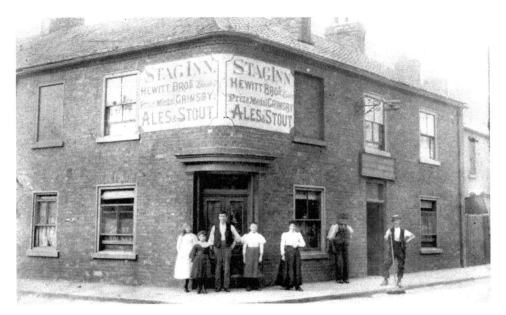

The earliest located reference of 1831 (*D.N.L. Gaz.* 21 Jan. 1831) is to premises, at the corner of St Leger Place/Dockin Hill Road, being titled 'Horse & Stag. On 20 Jan. 1911, the *Don. Gaz.* recorded the death of Elizabeth Crawford, aged eighty-eight, of the Stag Inn. She was Doncaster's oldest licencee having, been in the business thirty-eight years, spending eight years at the St James' Tavern and the remainder at the Stag. It was said that 'at both houses the management was undertaken by Mrs Crawford, the duties of host possessing no attraction for her husband'.

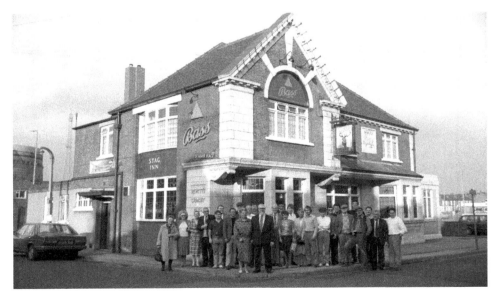

Plans were passed for Hewitt Bros to rebuild the Stagg in February 1935. To be found among the owners were C. D. Lockwood; W. H. Foreman; Hewitt Bros; Hammond United Breweries Ltd.

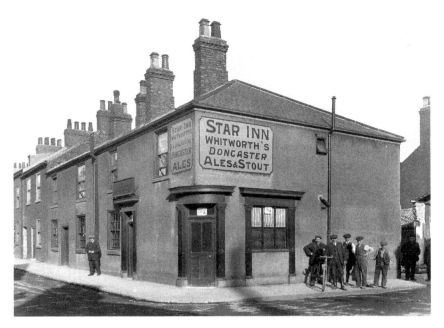

The Star, at the corner of St James' Street/Cemetery Road, may be traced to 1818 (*D.N.L. Gaz.* 16 June 1818 – 'House of Mr Teasdale, the sign of the Star, Spring Gardens'). Although the address is confusing, Teasdale is noted as licensee of the Star, at the correct address by Baines 1822 (*W. Riding. Dir.*).

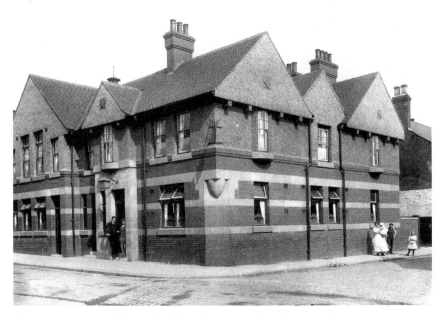

Plans were approved for rebuilding the Star to the designs of H. L. Tacon & Son, for Whitworth, Son & Nephew in February 1914.

The Star closed 17 October 1971 (*Don. E. Post* 18 October 1971). Dennis Carrier pulled the last pints; he had been at the pub since 1955. Noted previous owners were J. Maw; William Whitaker; W. Palmer; Henry Moorhouse; Andrew Cockin; Nicholson Bros; Whitworth, Son & Nephew Ltd; John Smiths Brewery.

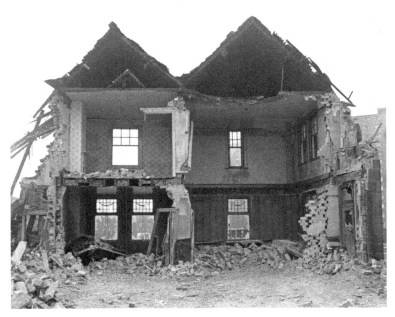

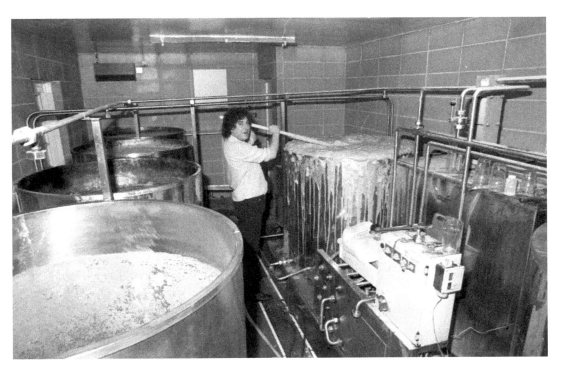

From the outset of Coopland's foray into the licensed trade during the early 1980s they decided to produce their own traditional ales. A professional mini-brewery was located at the rear of the Hallcross, Hall Gate, and in the capable hands of brewer Jim Butcher, Stocks Brewery produced Coopland's own range of beers – Stocks Best, Stocks Select and Stocks Old Horizontal.

Lager was on sale at both Coopland's houses due to a reciprocal trading agreement with brewing giant Camerons. Coopland's, in turn, sent their Stocks beers to Cameron's eight Tap and Spile pubs – secondary pubs refurbished and converted to real ale houses. Stocks Brewery was sold in 1996 (*Don. Star* 8 June 1996).

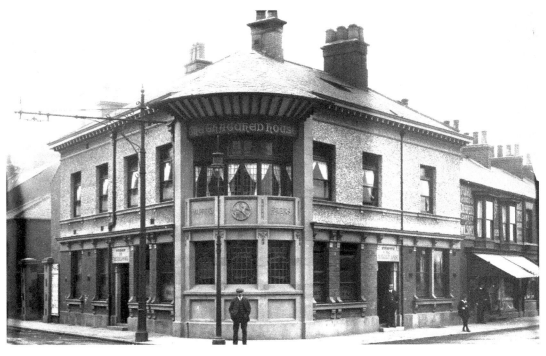

No trace now remains of the Thatched House, which formerly stood at the corner of Camden Street/St Sepulchre Gate. It was one of a number of pubs that sprung up as Doncaster expanded during the early years of the nineteenth century and gathered momentum when the Great Northern Railway Co. established a locomotive, carriage and wagon-building and repairworks in the town.

The *Don. Gaz.* Thursday 5 August 1965 states: 'Another link with Doncaster's past was broken on Monday [2 Aug. 1965] when the Thatched House hotel, St Sepulchre Gate, closed for the last time before its demolition to make way for road improvements. Customers many of them regulars for years thronged the three rooms to bid farewell to the licensee Mr Dennis Hayhurst and his wife Joan ... Mr Hayhurst, tenant for 4½ years said he was sorry to leave as he had made many friends.' A footnote in the article stated: 'The Thatched House built in the nineteenth century had a thatched roof until First World War when the thatch was removed as a precaution against fire.'

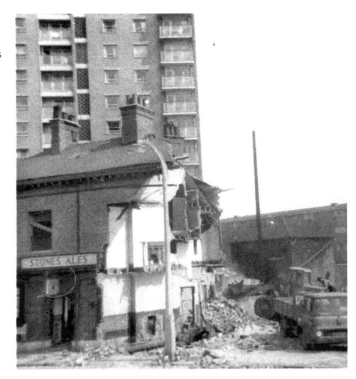

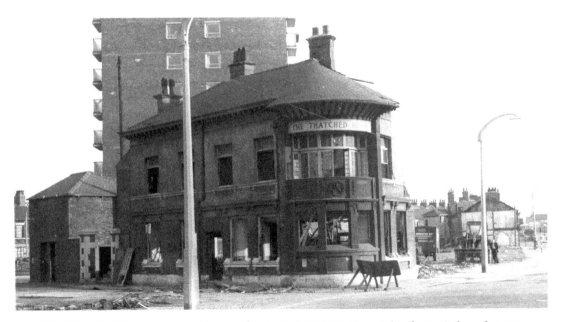

The Thatched House is traceable to at least 1836 (*D.N.L. Gaz.* 6 April 1836) the reference relating to the premises being titled 'Thatched Tavern'. Plans for alterations to the designs of F. Norman Master for Mappin's Masboro Old Brewery Ltd were approved in May 1913. The past owners also included William Stones Ltd.

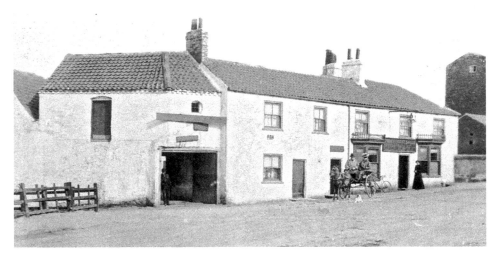

Numerous Doncaster pubs were rebuilt around the turn of the century as a result of street improvements or to comply with other important regulations. The first hurdle to vault was getting the plans approved by the Licensing Bench and the Three Horse Shoes at Town End did this quite successfully as detailed in the *Don. Gaz.*, 7 Feb. 1913: 'For some time past it has been known that it was intended to rebuild the Three Horse Shoes Inn at Town End, and Mr W. Baddiley now applied for approval of plans. The hotel was, said Mr Baddiley '... occupied by a previous tenant, the late Mr Towse [seen taking tea in one of the pictures here], for nearly 23 years, but unfortunately he died. With a change of tenant the owners had decided to rebuild the hotel on the old site ... Mr Tatham, of Rotherham, architect for the proposed alterations, said it was intended to rebuild the old hotel and to include an adjoin cottage. The plans ... provided for a tap room, 24 ft by 13 ft, a smoke room, 16 ft by 13 ft, a bar parlour, a kitchen and scullery and stabling on the ground floor, and on the first floor a club room 30 ft by 16 ft, five bedrooms and other accommodation. The plans were approved.'

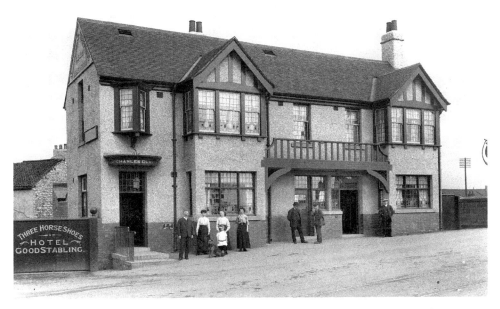

The history of the Three Horse Shoes' history extends back to at least 1783 (Sykes papers) and listed among the previous owners are Charles Anelay and Bradley & Co.

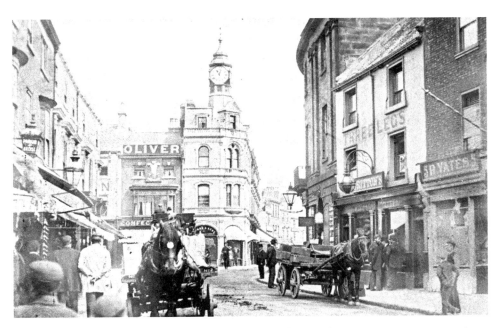

When a pub's name changes it is frequently asked whether this was necessary or not. A case in point is the Three Legs in St Sepulchre Gate, which became the Yorkist in 1969. The *Don. E. Post* reported: 'Brewers alter the shape of their legs', also revealing that this was an attempt to rid the premises of a bad reputation.

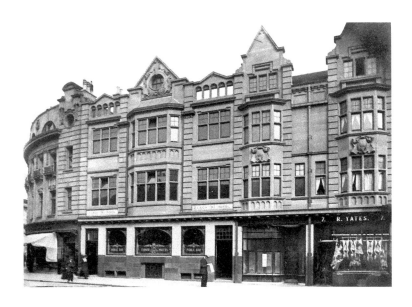

The Three Legs can be traced to at least 1782 (Hatfield III: 51). Plans were approved for rebuilding the premises for R. F. Hepworth in line with street widening in November 1912. Listed among the owners were Mary Bennett; Hodgson & Hepworth Ltd; Beverley Bros Ltd. All the name-changing drama, however, was shortlived as the premises closed completely in 1984.

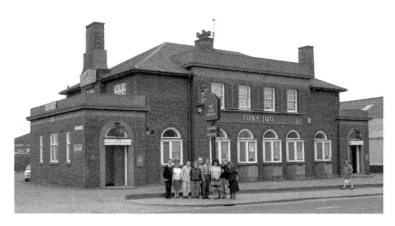

The licence of the George & Dragon, Marsh Gate, was transferred to a new pub, the Toby Jug, Mill Bridge, which opened on 2 November 1955, the *Don. Chron.* 3 Nov. 1955 providing the following details: '[The pub is] built in sand-faced, hand-made bricks with patent stone dressings it is roof tiled with Westmoreland green slates. A series of small projecting bay windows relieve the front elevation as well as enhancing the internal effect, and there are mock shutters, painted emerald green like the doors, at first floor level ... there are two large rooms with a central bar, each room having separate conveniences ... Lighting is fluorescent, and all the floors of the newest linotiles, laid in brilliant and original designs.' The premises were renamed the Palace c. 1991 and demolished in December 1996.

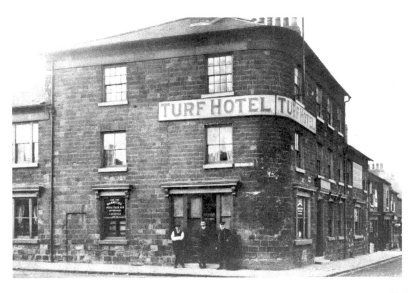

A number of Doncaster pubs reflect the town's horse racing associations, not only in their names but in the activities carried on at the premises. This was aptly demonstrated by the Turf Hotel at the Bentinck Street/St James Street corner, which had connections with noted colourful racing characters Lord George Bentinck and Lord Clifden, who stabled race horses there for a time.

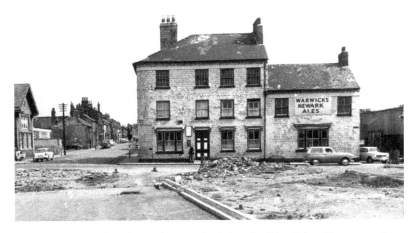

The Turf was constructed in the mid-1820s by joiner/builder John Glossop and was initially named St James' Tavern, the first Turf Tavern reference is 1829 (Hatfield III: 68). In 1830 Samuel King, a former stud groom and trainer to the Earl of Scarbrough at Sandbeck, erected extensive horse racing stables at the inn. The work was carried out by local stone-mason builder Joseph Lockwood and, at the time of completion, the stables were deemed the most complete and unsurpassed by any in the locality. King placed his brother-in-law, James Bowe, in charge. The latter, like King, had also earned a wide reputation as a stud groom and it was not long before a breeding stock was established. This was under the control of Lord George Bentinck, who relied on Bowe's judgement. The Turf Tavern stud was managed in an efficient manner and with an annual expenditure of up to £3,000 it produced some of the most noted winners of the turf.

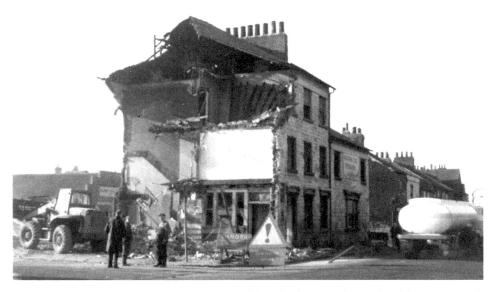

In subsequent years Lord Clifden used the stabling facilities at the Turf and he maintained its reputation by stabling many noted winners there.

Proposals were submitted in the late 1930s for rebuilding of the Turf Tavern. This went ahead almost twenty-eight years later than was planned, and on a different site, to make way for the Inner Relief Road. The new pub opened in College Road, 12 Dec. 1967, (*Don. E. Post* 11 Dec. 1967). The original pub was demolished during March 1968 (*Don. E. Post* 4 March 1968). Past owners included: Joseph Williamson; Joshua Arnold; James Milnthorpe; Alfred Eadon & Co. Ltd; Warwicks & Richardsons Ltd; John Smith's Brewery.

CHAPTER 6

VINE HOTEL – YORKSHIREMAN

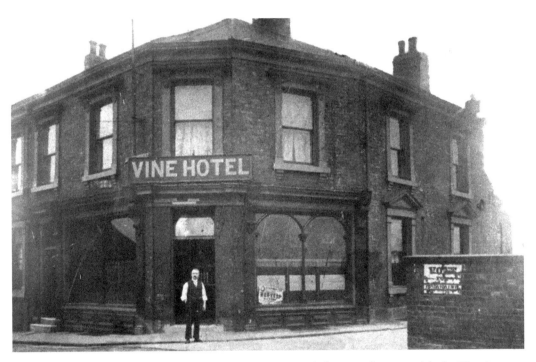

Certain Doncaster pubs had trouble at their inception and this was the case with the Vine in Kelham Street. At the Doncaster Brewster Sessions held during September 1890, a Mr Hall appeared on behalf of John Edward Hanson for a full licence for a house in Kelham Street. He remarked that at least 500 houses had been built since the first application. There was no house near it except in the borough, and the nearest was the Shakespeare's Head and the Star. In the West Riding the nearest was the Swan at Balby. Mr Hanson said that for many years he had applied for a licence. The chairman said that the feeling of the bench was it was a bona fide application, and what the bench proposed to do was to inspect the house and adjourn the matter. A month later the bench had viewed the premises and reported favourably. On opening the fully licensed premises were called the Vine.

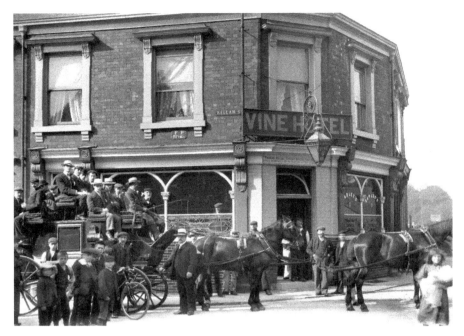

An earlier Vine Inn survived in Balby until 1851. The Kelham Street Vine probably existed as a beer house from around 1876 as the *D.N.L. Gaz.* 1 Sept 1876 notes: 'Application for a spirits licence for a large building in course of erection Kelham Street/Balby Bridge.' The pub was altered in 1922 and 1936, and demolished in March 2008.

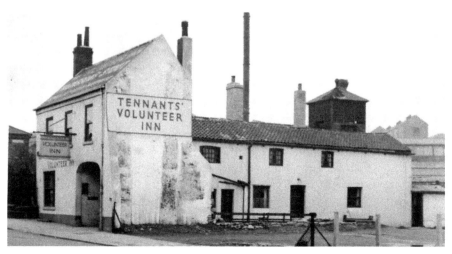

In the 1960s, when a large number of Doncaster's town centre pubs were demolished, several licences were transferred to new locations around the town. Such was the case with the Volunteer in French Gate, because when it closed in 1961 (*Don. Gaz.* 9 Feb. 1961) the licence was transferred to the 'Benbow' in Armthorpe Road.

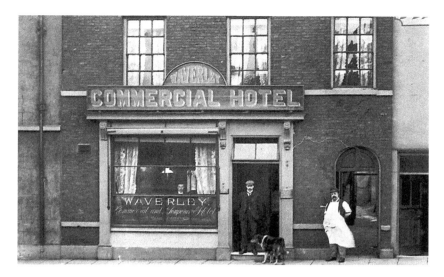

Several pubs only existed for short periods, so it is fortunate to include a picture of the Waverley, Market Place which was recorded there between *c.* 1909-20. The information is noted from entries in the *Don. Gaz. Dir.* After that time the business was transferred to St George Gate.

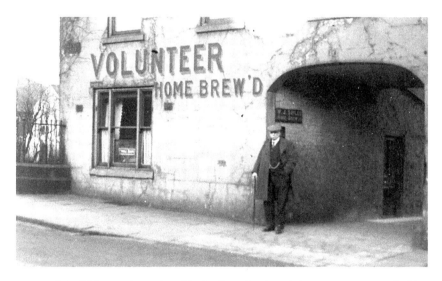

An account of the Volunteer's tussle with the licensing bench in 1936 was recorded by the *Don. Chron.*, 30 April 1936: '... the chief Constable said that the house was a free house, and the licensee brewed his own beer ... The barrelage was almost five a week and the house had its own private brewery ... It had been the property of the Corporation since about 1790, and there was evidence that it had been a public house a great deal earlier than that. It was agreed that if that landmark was to disappear from Doncaster it would be a most regrettable day in the history of Doncaster. The authority decided to renew the licence.' The Volunteer had existed as The Skinner's Arms from at least 1760. Among the past owners were Joseph Sayles and Tennant Bros (As lessees from Doncaster Corporation).

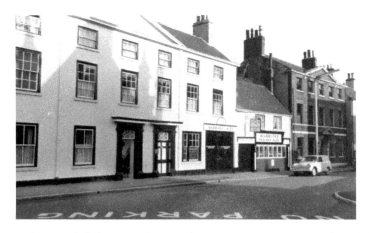

Not many people regarded the Waverley Hotel in St George Gate as a pub and the *Don. Gaz.*, 4 April 1921, under the heading 'Is it an inn?' reported: 'An action commenced at the Doncaster County Court on Wednesday turned on the question whether the Waverley Commercial Temperance Hotel, St George Gate, is a 'common inn' within the meaning of the law. A race-week visitor claimed £27 for the loss of a gold watch and chain which he alleged was stolen from his bedroom at the hotel, and Mr R. Hartley submitted that the place was not a common inn as the proprietress, Mrs Read exercised the right to refuse accommodation. Mr P. Allen was for the plaintiff and His Honour reserved judgement, intimating that he was prepared to hear arguments on the legal question.' The premises were closed *c.* 1970 and subsequently demolished for road improvements.

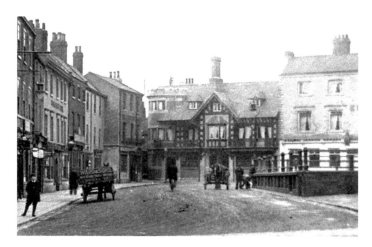

When old well-established Doncaster pubs disappeared in the 1960s for road improvements or redevelopment, each individual event was well recorded with pictures in the local paper, the *Doncaster Gazette*. 'Wellington meets its Waterloo' was the headline in the newspaper on 2 April 1964 when the Wellington in the Market Place closed and the following was reported: 'Last pints were pulled at the old Wellington Inn in a corner of Doncaster's Market Place. History was reversed. The Wellington had met its Waterloo – beaten by progress. It will soon be a heap of rubble before it makes way for a shopping development. It must have been a sad few moments on Monday when the landlord Mr John Hughes and his wife Hilda called: "Time, gentleman please," for the last time.'

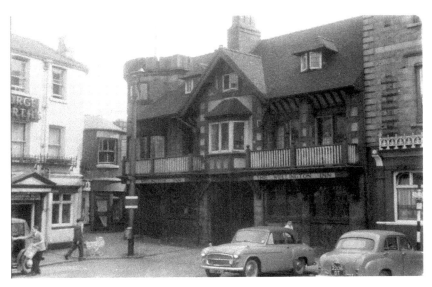

The Wellington Inn was formerly titled the Mitre and dated back to at least 1719. It traded as the Wellington from at least 1817 (*D.N.L. Gaz.* 21 Feb. 1817). The premises were altered in 1913 (*Don. Chron.* 27 June 1913) and closed 30 March 1964 (*Don. Gaz.* 2 April 1964).

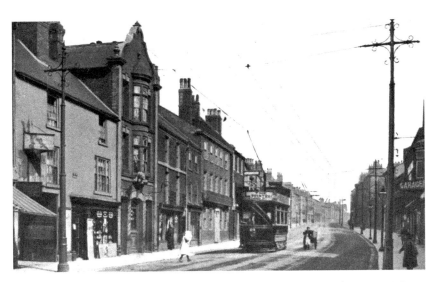

The White Bear's sign in Hall Gate was featured in the *Don. Chron.*, 15 May 1885: 'No sign in Doncaster has attracted so much attention as the old Bear, and at the races he was viewed with more curiosity than "the favourite" himself. Being "the observed of all observes" ... The figure, we believe, is carved out of oak, and at the recent sale by auction of the furniture and fixtures at the White Bear Inn, bruin had also to be brought to the hammer ... and it was ultimately knocked down to Mr Johnson, builder, for 31 15s ... As to the house itself, it is now in the course of demolition, and is to be replaced by a new structure, the whole work being entrusted to Mr Johnson, builder.'

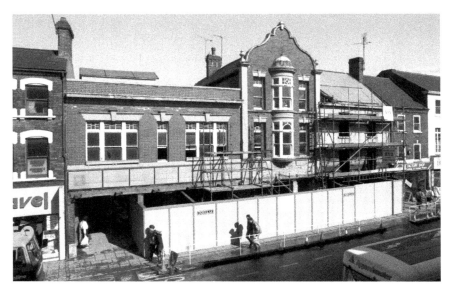

Hatfield III: 72 provides an early reference of 1779 for the White Bear, which was altered in 1885, 1925, 1959 and 1988. Former owners were George Nicholson, and Tadcaster Tower Brewery Co. Ltd.

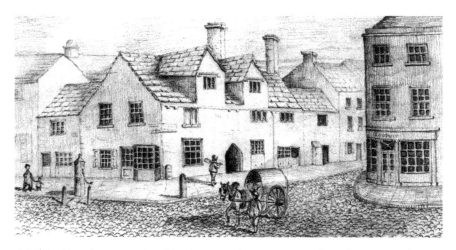

A White Hart has not existed in Doncaster's town centre since the 1960s when a pub with that title was demolished for the construction of the Arndale (now French Gate) Centre. This however, was not its original site. It had existed on another French Gate site, then on the High Street/St Sepulchre Gate corner prior to returning to French Gate. Further, the closure and opening dates of number two and three 'White Harts' may have overlapped each other. The inn existed on the first French Gate site under various guises, the Hynd on the Hop, the White Hynd and Hart on the Hynd, and may be traced to the fifteenth century. Shortly before 1794, when the original pub's name was changed to the Mail Coach, one of its former occupants, Ben Walker, moved to premises at the High Street/St Sepulchre Gate corner and established White Hart number two (seen above).

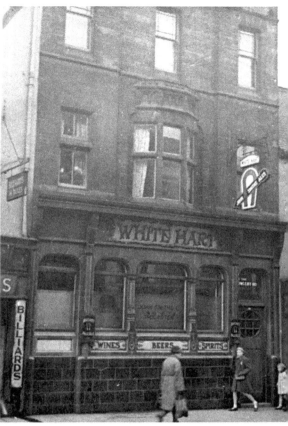

Above left: The lifespan of White Hart number two was short, as Doncaster Corporation required the premises for street widening and it was vacated in 1819. Hatfield informs that the inn's former landlord, Thomas Jenkinson 'removed to the White Hart in French Gate (formerly the Doncaster Arms). This is White Hart number three, and, as previously stated, it is unclear whether this pub was operational while number two was still trading. In a vague statement about Ben Walker, number two's founder, Hatfield observed: 'His sole aim was to outlive a formidable opponent.' Thus suggesting two White Harts were operating in competition.

Above right: White Hart number three besides carrying a previous name of the Doncaster Arms was also the site of another old hostelry, the Three Cranes. This is confirmed by Tomlinson (1887): 'The "Three Cranes", where Charles I stayed when in Doncaster, occupied a site where the present "White Hart" and adjoining shops now stand.' White Hart number three's front portion was rebuilt in 1902, the rear section in 1903. Past owners included Samuel Johnson & Sons and John Smith's Brewery. The premises closed in March 1963.

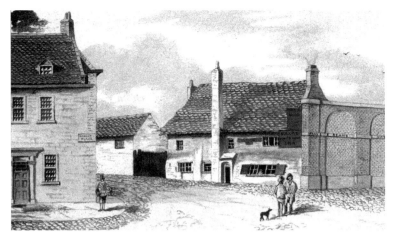

New buildings erected in the Market Place during the latter half of the nineteenth century caused several pub casualties including the White Horse in High Fisher Gate, which dated back to at least 1770 (*Don. Courtiers* 1770 Vol. IV: 241). The last tenant was Thomas Bullas who entered the house before 1841 as the *D.N.L. Gaz.* 19 Feb 1841 mentioned the death of his wife: 'Saturday last, died Elizabeth, wife of Thomas Bullas of the White Horse.' The house was still standing in 1868 in which year the death of Thomas Bullas is recorded in the *D.N.L. Gaz.* 21 March 1868. The inn appears to have gone to the ground in the same year (Hatfield III: 89). Past owners included Doncaster Corporation.

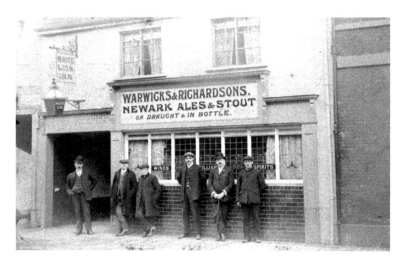

While the White Lion Inn, St George Gate, was being altered during 1913, several discoveries were made. In a room once used for billiards, a painting of a raging white lion was found. A Mr Stott, the manager for Warwicks & Richardsons, the pub's owners, instructed the builders to cut out the panel. It was suggested the painting was the work of the artist J. F. Herring who had a penchant for painting public house signs and panels, and samples of his work were to be found at other Doncaster inns. In another room were three paintings in panels which had been a well known feature of the house for years. Later, as it was attempted to cut out the White Lion panel, the wall collapsed and the painting was destroyed.

A White Lion thrived in French Gate until 1782 and a water rent reference of 1796 is the earliest one found for the St George Gate pub. The *Don. E. Post* of Thursday 24 September 1970 reported: 'The last pint will be pulled [at the White Lion] at closing time on Saturday night ... And Saturday will mark the retirement of George and Beatrice Smith who have run the White Lion for more than 10 years.' Among the past owners were Alfred Eadon and Co. Ltd and Warwicks & Richardsons Ltd.

In the 1950s there were eight pubs in French Gate; now there is only the White Swan. Hatfield reveals that an inn of this name formerly existed in South Parade and then the Market Place until around 1799. The *D.N.L. Gaz.* 10 November 1808 provides us with the earliest located reference – 1808 – for the pub on the French Gate site.

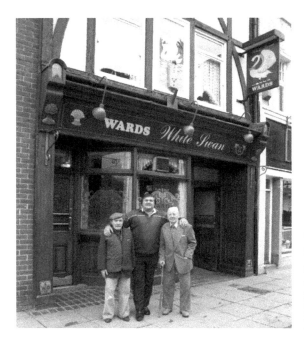

The White Swan was altered in 1931 and its owners from the latter half of the nineteenth century have largely been based in Sheffield: William Bradley's Soho Brewery Company and Wards Brewery.

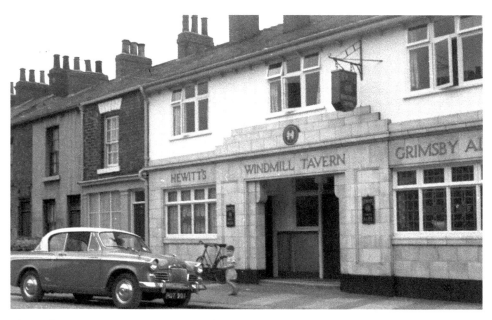

This pub in Bentinck Street (originally known as St James' Street South) was most likely named after a windmill that existed near the site and is shown on a plan of 1852. The licensed premises stretched back to at least 1855 (*D.N.L. Gaz.* 12 Oct. 1855). Alterations and additions are noted at the premises in 1893 and 1935, before they were demolished in January 1973. Among the owners were Swan Whittaker & Co.; Hewitt Bros; Hammond United Breweries Ltd. The Windmill was granted a full licence in 1949 (*Don. Chron.* 14 April 1949).

William Sheardown states in an article 'Moat and Mound – A defence of the town of Doncaster,' published in the *D.N.L. Gaz.,* 8 Oct. 1869: 'In 1707, a bar belonging to the Woolpack Inn is described as situated on the highway leading from the stone bridge to Sunny Bar.' This is the first located reference to the Woolpack on the south side of the Market Place. The Woolpack sign was popular in wool-producing areas, and today it serves as a reminder of how much the national wealth at one time depended on the wool trade.

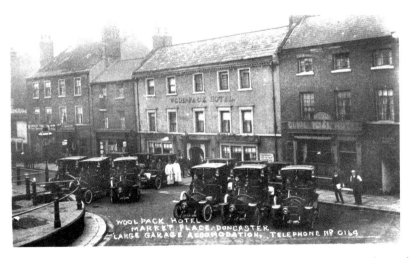

Hatfield in his *Historical Notices* gives the impression that during the late eighteenth century the Woolpack was a prestigious inn frequented by gentlemen, societies and other groups. Additionally, he records a newsroom at the Woolpack and a sale being held there in 1857. Sales and inquests were, of course, regularly held in many local pubs in the past. One of the most important events, which arguably boosted trade at the Woolpack, was the erection of a theatre in the Market Place during 1776, virtually on the pub's doorstep.

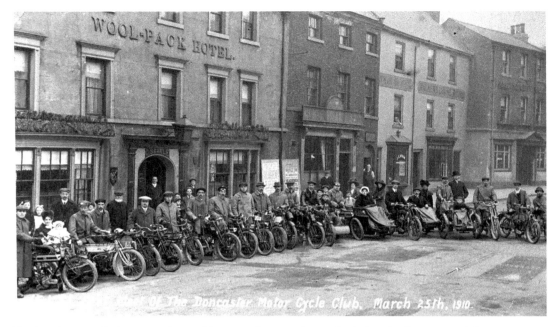

During the twentieth century it would appear from a picture depicting the first meet of the Doncaster Motorcycle Club in 1910, that business carried on much the same as before. Fortunately, the Woolpack has undergone no nasty alterations or rebuilding as was common with a number of pubs in other areas of the town. The only notable alteration occurred during 1880, when an area at the rear was developed. In the 1950s, the Woolpack was one of four pubs that were listed, the other three being the Waverley, Salutation and Reindeer; two of these have since been demolished.

In a Doncaster Brewster Session of 1900 (*Don. Chron.* 31 Aug. 1900) it was stated: 'The rebuilding of the [Crown, Church Street] had become imperative because of the scheme of street improvement which the Corporation were pursuing, under which a new street [Greyfriars Road] would be made from the Electricity Works to Fisher-gate, and which rendered it necessary for the Corporation to purchase nearly the whole of the present licensed premises of the Old Crown, which would be thrown into the roadway which it was intended to make. It was solely with a view to assisting the Corporation that Mr [Thomas W. G.] Hewitt had agreed to give up his present premises.' A Crown inn had formerly existed in the Market Place.

The Church Street Old Crown (later Ye Olde Crown) extended back to at least 1795 (*D.N.L. Gaz.* 31 Oct. 1795). The new premises in Greyfriars Road were designed by local architects, Athron & Beck and a retrospective for the year 1902 published in the *Don. Gaz.*, 2 Jan. 1903, mentions that the Old Crown had been rebuilt and set back in that year. The name was changed to Greyfriars Inn, Nov. 1996.

Ye Olde Crown, which closed in 1998, has recently been converted for commercial use being presently occupied by Max Wildsmith Saddlery and Country Clothing. Previous owners of the licensed premises included Hewit Bros.

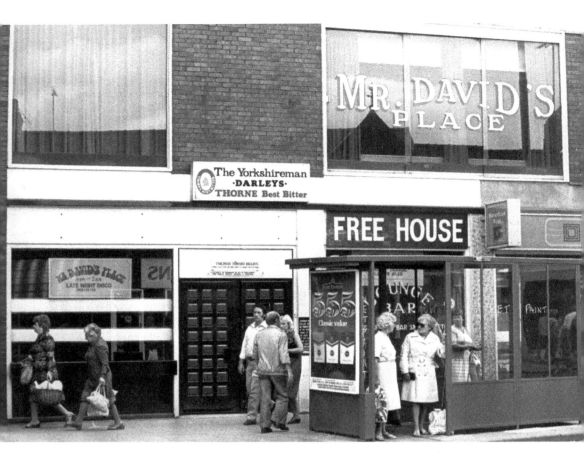

Few Doncaster pubs have disappeared in a blaze of controversy but this was the case with the Yorkshireman on Silver Street in 1986. The pub dated from at least 1978 (*Don. E. Post* 21 April 1978) and the *Don. Star,* 13 June 1986, reported: 'A Doncaster nightclub and pub [the Yorkshireman] are closed today, with their owner's company having gone bust. A company owned by well known Doncaster entrepreneur Ken Davis was wound up in the High Court in London, with debts of more than £56,000 ... Mr Davis confirmed today both the Yorkshireman public house and Mr Davis's nightclub, on the same premises in Silver Street, are now closed and up for sale.' New premises under different ownership opened on the site as the GalleryF 13 April 1988.